LONDON

City Highlights

teNeues

Imprint

Texts: Yasemin Erdem
Service: Marianne Bongartz, MaBo-Media, Cologne
Translations: Alphagriese Fachübersetzungen, Dusseldorf; Susanne Olbrich (Service)
Editorial management: Hanna Martin, Susanne Olbrich
Layout: Susanne Olbrich, Anne Dörte Schmidt
Imaging and Pre-press: Jan Hausberg, Martin Herterich

Photo credits: Peter Clayman, beside: Arpingstone (p. 30); Arts Council Collection, Hayward Gallery, London: © Barbara Hepworth, Spring [1966], Bowness, Hepworth Estate (p. 45), © Roger Hiorns, Nunhead [2004] (p. 45), © Phillip King, Point X [1965] (p. 45); Alberto Arzoz (p. 40); Borris Bags (pp. 59 b. r., 60–61); Roland Bauer (pp. 107 b. l., 118 b. r., 119); Roland Bauer/ Martin Kunz (p. 13); Lidia Casas (pp. 127, 144–149, 157 t. r.); Caro/Oberhaeuser (p. 6); Caro/Ruffer (pp. 12 t. l., 27, Backcover l.); courtesy Baltic Restaurant (pp. 72–73); courtesy Coco de Mer (pp. 84–85); courtesy Courthouse Hotel Kempinski (pp. 5 t. r., 108–109); © Dean and Chapter of Westminster (pp. 18–21); courtesy Debenhams PLC (p. 81 b. l.); © Anthony Devlin (p. 139); courtesy Dunhill (pp. 88–89); courtesy Knightsbridge Hotel (pp. 107 b. r., 120–121); courtesy The London Aquarium (pp. 130–131); courtesy Madame Tussauds London (pp. 134–135); © The National Gallery, London Photo: Phil Sayer (pp. 35 b. l., 36–39); © National Theatre, Photo: Mike Smallcombe (p. 46 t. l.); © National Theatre, Photo: Timothy Soar (p. 46 t. r., 47); courtesy Network London & Sketch (pp. 62–65); courtesy One Aldwych Hotel (p. 10); courtesy The OXO Tower Restaurant, Bar and Brasserie (p. 5 t. l.); courtesy The Rookery (pp. 116–117); courtesy Tate (pp. 52–53); courtesy Threadneedles (p. 118 t. r.); courtesy Virgin Retail (pp. 92–93, 153 t. l.); Katharina Feuer (pp. 76 t. r., 78–79); Laurie Fletcher (pp. 59 b. l., 66–67, Backcover r.); Marcus Ginns (p. 54); Gavin Jackson (p. 106, 110–115, 122–125); Sam Lloyd (pp. 15 b. l., 26); Peter Mackertich (p. 41); Media Centre © Sarah Williams (pp. 138, 139 b.); Susanne Olbrich (pp. 8 t. r., 35 b. r., 55, 82–83, 152, 157 t. l.); Karsten Thormaehlen (pp. 14, 28, 48–51, 100–101); Heike Wild (pp. 12 t. l., 150 t. r., 154 t. r., 155 t. l.); Nigel Young / Foster+Partners and Foster+Partners as Architects (p. 32 t. l.); Herbert Ypma (pp. 68–69)
Cover: Peter Clayman

Content and production: fusion publishing GmbH, Stuttgart . Los Angeles
www.fusion-publishing.com

teNeues Publishing Group

teNeues Verlag GmbH + Co. KG
Am Selder 37
47906 Kempen, Germany
Tel.: 0049 / (0)2152 / 916 0
Fax: 0049 / (0)2152 / 916 111

teNeues Publishing Company
16 West 22nd Street
New York, NY 10010, USA
Tel.: 001-212-627-9090
Fax: 001-212-627-9511

teNeues Publishing UK Ltd.
P.O. Box 402
West Byfleet, KT14 7ZF
Great Britain
Tel.: 0044-1932-403509
Fax: 0044-1932-403514

teNeues France S.A.R.L.
93, rue Bannier
45000 Orléans, France
Tel.: 0033-2-38541071
Fax: 0033-2-38625340

Press department: arehn@teneues.de
Tel.: 0049 / (0)2152 / 916 202

www.teneues.com

Copy deadline: 1 February 2007

Bibliographic information published by Die Deutsche Bibliothek. Die Deutsche Bibliothek lists this publication in the Deutsche Nationalbibliografie; detailed bibliographic data is available in the Internet at http://dnb.ddb.de.

ISBN 978-3-8327-9194-0

Printed in Italy

Right page:
Tower Bridge

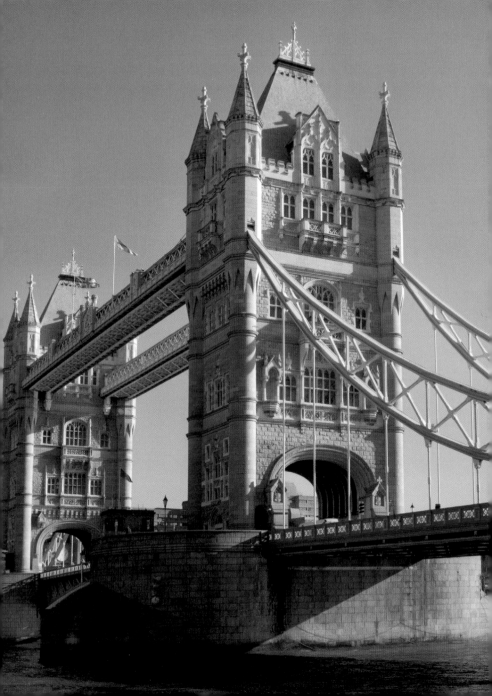

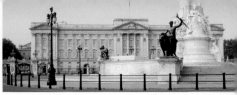

Introduction 6

Sightseeing

Houses of Parliament. 16
Westminster Abbey. 18
Buckingham Palace 22
Westminster Cathedral 24
St Paul's Cathedral 26
Tower of London 28
Tower Bridge 30
City Hall . 32

Culture:
Museums, Galleries, Theaters, Cinemas

National Gallery 36
Royal Opera House 40
British Museum 42
Hayward Gallery. 44
National Theatre. 46
Shakespeare's Globe Theatre 48

Tate Modern 50
Tate Britain 52
Royal Albert Hall 54
Design Museum 56

Restaurants, Cafés, Bars, Clubs

Automat . 60
Sketch . 62
mo*vida . 66
Yauatcha. 68
Moro . 70
Baltic . 72
Wagamama. 74
Tom's Delicatessen 76
The River Café 78

Shopping

Covent Garden 82
Coco de Mer. 84
The Tea House 86

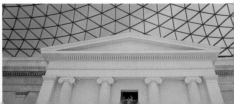

Dunhill . 88
Hamleys 90
Virgin Megastore 92
Rococo Chocolates. 94
The Conran Shop 96
Daunt Books 98
Harrods. 100
Borough Market 102
Camden Market 104

Hotels

Courthouse Hotel Kempinski. 108
Brown's Hotel. 110
Claridge's 112
B+B Belgravia. 114
The Rookery. 116
Threadneedles 118
Knightsbridge Hotel 120
The Lanesborough. 122
Blakes. 124

What else?

British Airways London Eye 128
London Aquarium 130
Hyde Park 132
Madame Tussauds London 134
The Regent's Park 136
Lord's . 138
Primrose Hill 140
Hampstead Heath. 142
Greenwich Park 144
Kew Gardens 146
Richmond Park 148

Service

Useful Tips & Addresses 150
Map. 158

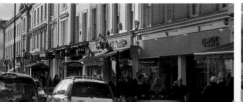
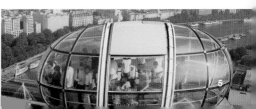

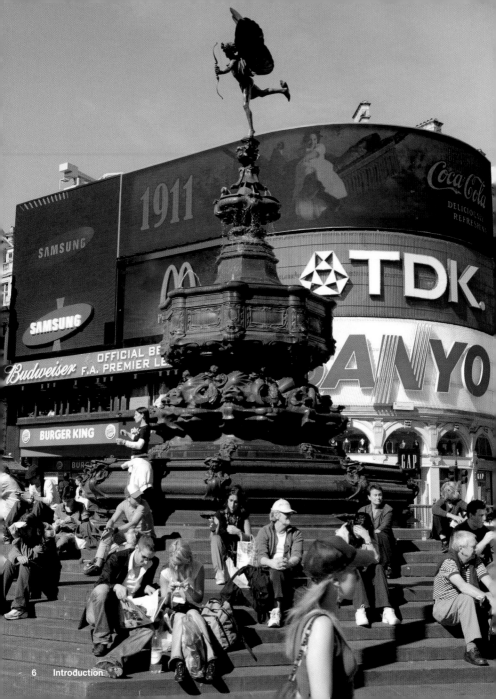

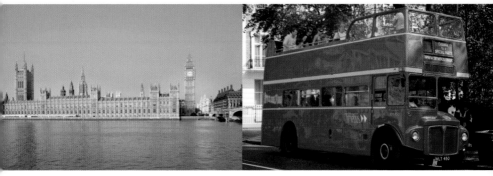

Left page: Piccadilly Circus
Right page: Left Houses of Parliament and Big Ben, right red sightseeing bus

A Star without Airs

"After you!"... "No, after you!" ... "No, please, after you!" ...—this is the gist of a tale that caricatures exaggerated politeness. In London though, politeness is neither a cliché nor exaggerated, but just a way of life. It may happen that someone excuses himself even though you just stepped on his feet, but this will probably be accompanied by a roguish wink of the eye. London is a relaxed city. Understatement and non-conformity can be felt everywhere. The atmosphere is vibrant, sometimes offbeat, and you meet people of every shade and color. The many green oases and possibilities for retreat—such as Hyde Park—are pleasant in the middle of the city. Although there is always a lot going on in London (which often makes it hard to get a table in a restaurant even during the week), the underlying impression is one of calmness. And this exists in spite of the frequent necessity to stand in lines—cutting in is absolutely frowned upon. People just stoically endure their waiting time. London has an independent sense about it; after a few days here, you will return home a bit more content and elated, without being able to say exactly why. Even if you engage in activities within modest limits, you will still spend quite a lot of money. Why is this? Perhaps because of the unbelievable variety that this city offers, coupled with its' residents remarkable serenity and self-irony. London inspires and refreshes. The metropolis is a star without airs.

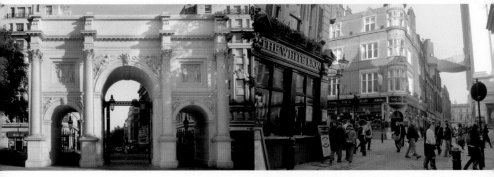

Left page: Left Marble Arch, right Covent Garden
Right page: Millennium Bridge and view of St Paul's Cathedral

Une star sans manières

« Après vous ! » … « Non, après vous ! » … « Non, je vous en prie, après vous »… – c'est à peu près comme cela qu'on pourrait caricaturer la courtoisie exagérée. Mais à Londres, la courtoisie n'est ni un cliché ni exagérée, elle est vécue. Il peut arriver que quelqu'un s'excuse parce que vous venez de lui marcher sur les pieds. Mais il vous lancera tout de suite un clin d'oeil ironique. Londres est une ville détendue. L'art de la litote et du nonconformisme y sont pratiqués partout ; ici, la vie est colorée, même décalée, et on rencontre des gens de toutes les couleurs. Ce qui est agréable, ce sont les nombreuses oasis vertes et coins de retraite – comme par exemple Hyde Park – au centre ville. Bien qu'il s'y passe toujours beaucoup de choses (même en semaine, il est souvent difficile d'avoir une table dans un restaurant), on a l'impression d'un calme sous-jacent. Et ceci malgré les files d'attentes fréquentes – il est absolument inadmissible de resquiller, on attend avec une patience stoïque. Londres rayonne d'indépendance; après quelques jours passés ici, on rentre un peu plus satisfait, plus dynamique, sans pouvoir dire exactement pourquoi. Même si l'on s'en tient à des activités modestes, on dépensera quand même beaucoup. A quoi cela tient-il ? Peut-être à l'incroyable diversité qu'offre cette ville, conjuguée à la remarquable nonchalance et à l'autodérision de ses habitants. Londres inspire, rafraîchie, cette métropole est une star sans manières.

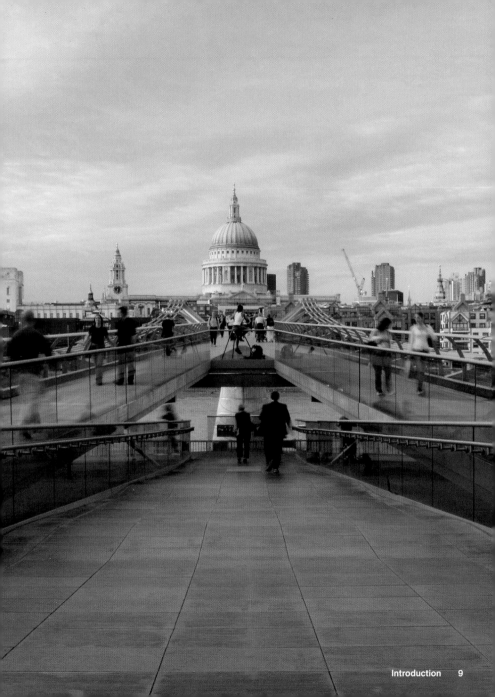

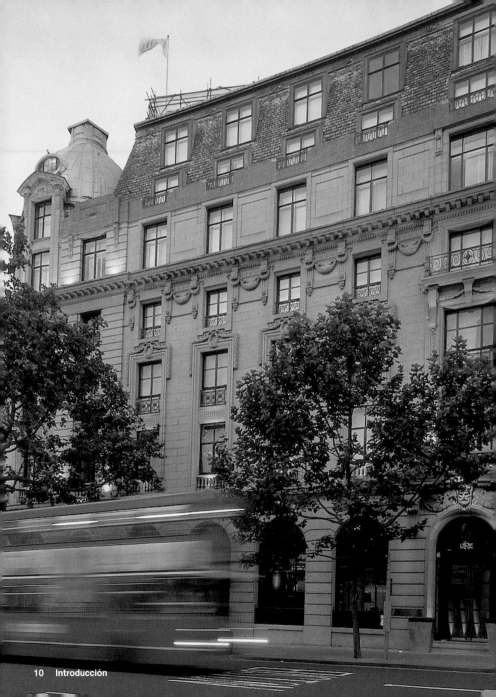

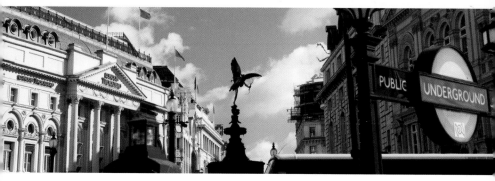

Left page: One Aldwych Hotel
Right page: Piccadilly Circus

Una estrella sin artificio

"¡Usted primero"... "No, ¡usted!"... "No, por favor, ¡usted!"... algo así se menciona en un relato que caricaturizaba la cortesía desmesurada. En Londres, sin embargo, la cortesía ni es cliché ni exageración, sino modo de vida. Puede ocurrir, que alguien se disculpe, aunque haya sido usted el que le ha pisado, pero probablemente las disculpas irán acompañadas por un guiño de malicia. Londres es una ciudad relajada. En todos los rincones se aprecia la tendencia a minimizar y el inconformismo, se respira una atmósfera variopinta y singular, y se topa con personas de todos los colores. Oasis verdes para refugiarse, como por ejemplo el Hyde Park, están cómodamente ubicados en plena ciudad, Aunque Londres está cargado de vida (incluso entre semana es difícil encontrar una mesa en un restaurante), se advierte de forma subliminal una sensación de reposo. Y todo esto a pesar de tener que estar a menudo de pie haciendo cola; aquí la espera se aguanta estoicamente y colarse es pecado mortal. Londres irradia algo distinto; tras unos días de estancia se regresa más satisfecho y animado, sin saber decir exactamente por qué. Ahora bien, cada actividad, incluso la más modesta, conlleva gastos considerables. ¿Y a qué será debido? Tal vez a la increíble variedad que esta ciudad ofrece, junto con la imperturbable compostura y propia ironía de sus habitantes. Londres inspira y revitaliza, la metrópoli es una estrella sin artificio.

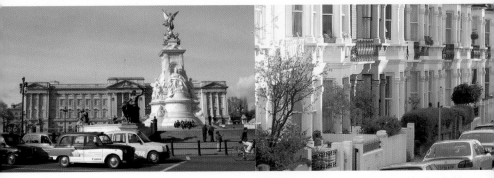

Left page: Left Buckingham Palace with Victoria Monument, right typical British town houses
Right page: Swiss Re Tower (The Gherkin)

Una superstar senza affettazione

"Dopo di lei!" ... "No, dopo di lei!" ... "No, la prego, dopo di lei!" ... così più o meno faceva una storiella che caricaturava la cortesia esagerata. A Londra però la cortesia non è né un cliché né esagerata, è semplicemente lo stile di vita. Può sì capitare che qualcuno si scusi perché che gli abbiamo calpestato il piede, ma è probabile che il tono della voce sia a metà tra l'ironico e il divertito. Londra è una città rilassata. L'anticonformismo e il "non prendere le cose troppo sul serio" si intuiscono ovunque, la città è variopinta (anche nel colore della pelle dei suoi abitanti) e a volte lievemente pazzerella. Molto gradevoli le numerose oasi verdi e le possibilità di "staccare" in piena città, il tipico esempio è Hyde Park. Nonostante la scena sia sempre assai animata (è difficile trovare tavoli liberi nei ristoranti anche durante la settimana), si avverte comunque la sensazione subliminale della tranquillità. Non disturbano nemmeno le frequenti code: l'attesa si sopporta stoicamente, e saltare la fila è fuori discussione. Londra irradia qualcosa di unico e indipendente: dopo alcuni giorni qui, si ritorna ricaricati e contenti, senza nemmeno sapere di preciso perché. Eppure ogni attività, anche la più modesta, comporta delle spese non trascurabili. E allora qual è la spiegazione? Forse l'incredibile varietà che la città offre, unita alla notevole compostezza e autoironia dei suoi abitanti. Londra ispira e rinfresca, la metropoli è una superstar, ma senza affettazione.

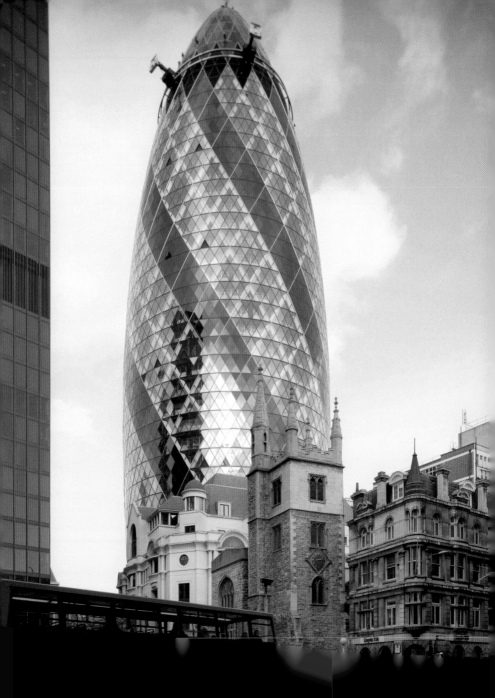

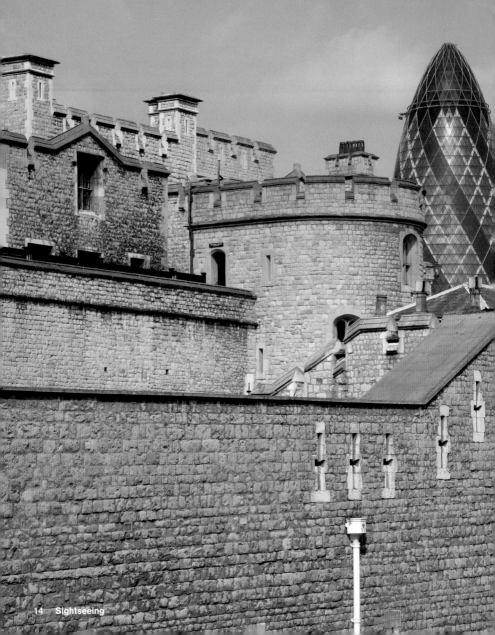

Sightseeing

It's actually impossible not to see any sights in Central London. Buildings with a rich tradition like the Tower, the royal palaces, and the cathedrals compete here with modern architecture such as the Swiss Re Tower. While the latter can be examined at any time for free, the sights that cost money should be visited during the week to avoid waiting in long lines.

Au centre de Londres, il est pratiquement impossible de ne pas tomber sur des monuments. Des bâtiments de tradition comme le Tower, les palais royaux et cathédrales rivalisent avec de l'architecture moderne comme le Swiss Re Tower. Tandis qu'on peut toujours visiter ce dernier librement, la visite des curiosités payantes est plutôt recommandée pendant la semaine pour éviter des temps d'attente trop longs.

No encontrar nada que merezca la pena visitar en Londres es absolutamente imposible. Edificios tradicionales como la Torre, los palacios reales y las catedrales compiten con obras de arquitectura moderna como la Torre Swiss Re. Mientras que a ésta se puede acceder gratuitamente en cualquier momento, los primeros se recomienda visitarlos entre semana, para evitar largas esperas.

Non trovare nulla che non valga la pena vedere nel centro di Londra è semplicemente impossibile. Costruzioni storiche come la Torre, il Palazzo Reale e la Cattedrale fanno concorrenza a opere di architettura moderna come la Torre Swiss Re. Mentre queste ultime si possono osservare liberamente in qualsiasi momento, per le prime (a pagamento) è consigliabile muoversi durante la settimana per evitare lunghe code.

Left page: Tower of London and in the background Swiss Re Tower
Right page: Left St Paul's Cathedral, right Millennium Bridge leading towards St Paul's Cathedral

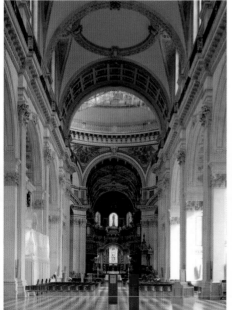
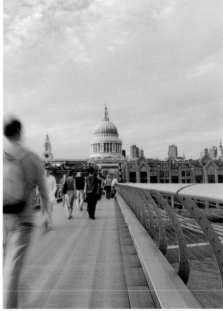

Houses of Parliament

Palace of Westminster
London
SW1A 0AA
Westminster
Phone: +44 / 20 / 79 83 40 00
www.parliament.uk

Opening hours: Guided tours Aug–Sept Mon–Sat,
caucus Mon–Fri depending on schedule
Admission: Guided tours through the Parliament £ 9,
concessions £ 7, caucus free
Tube: Westminster
Map: No. 25

Above all, the seat of parliament is famous because of its clock tower, Big Ben. Its unmistakable melody sounds at every full hour. Guided tours are only possible in the summer weeks when there are no sessions, but it is possible to follow the debates in both houses from the visitors' gallery.

Le siège du parlement est surtout connu pour sa tour de l'horloge, Big Ben, qui laisse entendre sa mélodie typique toutes les heures. Des tours guidés ne sont possibles que pendant la pause parlementaire en été, mais sur les rangs des visiteurs, on peut suivre les débats des deux chambres du parlement.

La sede del Parlamento es famosa sobretodo por su Torre del Reloj, el Big Ben, cuya inconfundible melodía resuena cada hora. Las visitas guiadas sólo tienen lugar durante las semanas de vacaciones de verano, en las que el Parlamento no se reúne, pero es posible presenciar los debates desde las tribunas para visitantes.

La sede del Parlamento è famosa soprattutto per il suo campanile, il Big Ben, la cui inconfondibile melodia risuona ogni ora. Le visite guidate sono disponibili solo nelle settimane estive in cui il Parlamento non si riunisce, tuttavia è sempre possibile assistere alle sedute da apposite tribune.

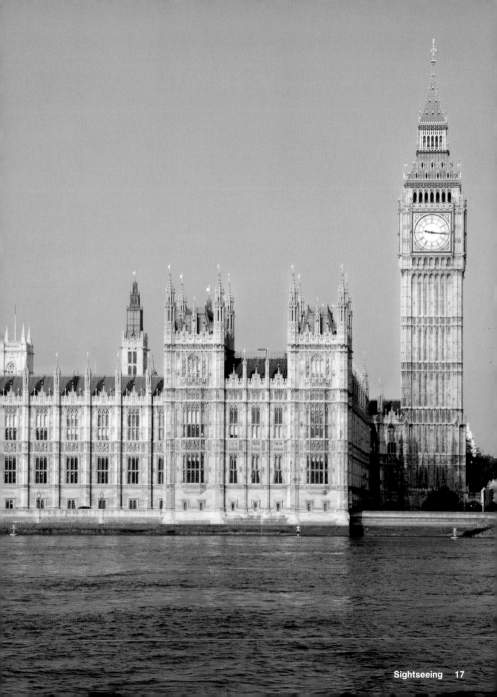

Westminster Abbey

20 Dean's Yard
London
SW1P 3PA
Westminster
Phone: +44 / 20 / 76 54 49 00
www.westminster-abbey.org

Opening hours: Daily except Sun – see website for various closing hours
Admission: £ 10, concessions £ 7
Tube: Westminster, St James's Park
Map: No. 57
Editor's tip: From the Cloisters you reach a quiet tree-lined courtyard.

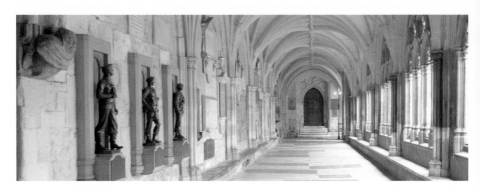

The best time to visit the famous Gothic church is during a service or for one of the classical music concerts. Since 1066, almost all of the British kings and queens have been crowned here. They also were buried here for 700 years. The kingdom's most famous writers are commemorated at Poet's Corner.

On devrait visiter cette église gothique très connue pendant l'office ou lors d'un des concerts classiques. Depuis 1066, presque tous les rois et reines britanniques ont été couronnés, et, pendant 700 ans, aussi inhumés ici. Dans le Poet's Corner, on honore les plus grands poètes du Royaume.

El mejor momento para visitar la legendaria iglesia gótica es durante una celebración religiosa o en algún concierto de música clásica. Desde el año 1066 casi todos los reyes y reinas ingleses han sido coronados aquí, y durante 700 años se les dio también sepultura. En el Poet's Corner se recuerda a los grandes poetas del reino.

I momenti migliori per visitare la celebre chiesa gotica sono durante le messe o i concerti classici. Dal 1066 a oggi sono stati incoronati qui quasi tutti i re e le regine inglesi, e per 700 anni hanno anche trovato anche la loro sepoltura. Nel Poet's Corner si rende omaggio ai più grandi poeti del Regno.

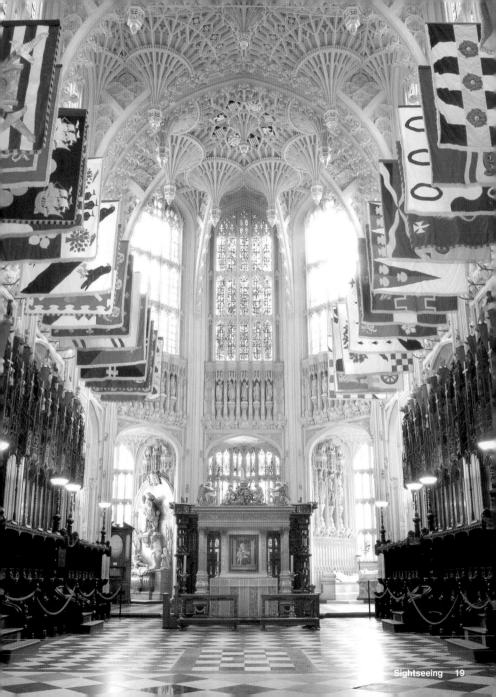

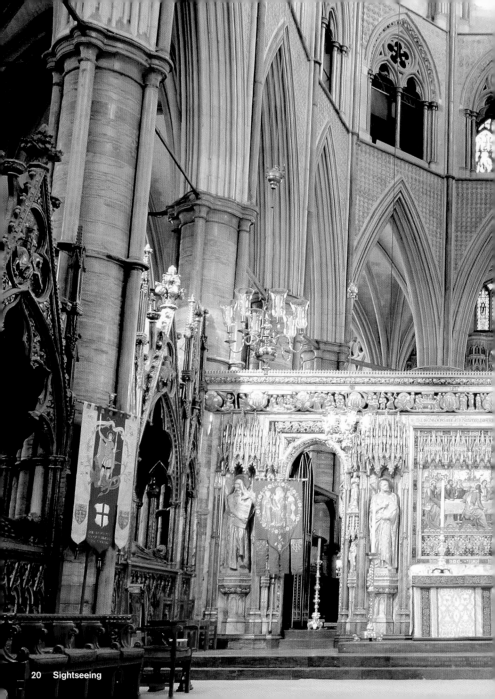

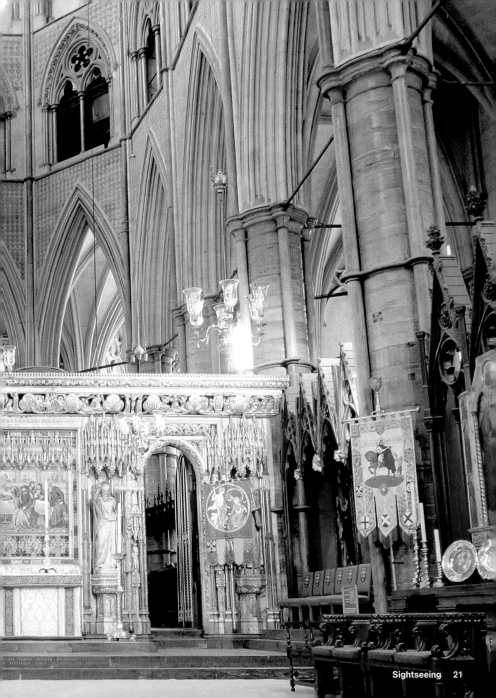

Buckingham Palace

London
SW1A 1AA
St James's
Phone: +44 / 20 / 77 66 73 00
www.royal.gov.uk

Opening hours: Palace July–Sept 9.45 am to 6 pm; Changing the Guard daily May–July 11.30 am and on alternate dates throughout the rest of the year
Admission: £ 15, children 5–17 years £ 8.50, children (5 and under) free
Tube: Victoria, Green Park, St James's Park
Map: No. 9

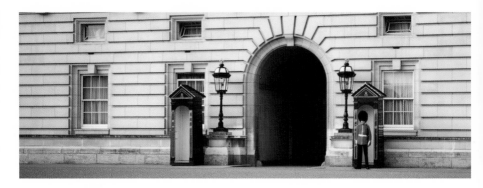

The Duke of Buckingham's town house, which was built in 1703, became the official royal residence in 1837 after many renovations. In August and September, when the royal family is on vacation, the palace—including the art collection and royal gardens—is open to the public.

Après de nombreuses modifications, l'hôtel de ville du Duc de Buckingham, construit en 1703, est devenu la résidence royale officielle en 1837. En août et en septembre, quand la famille royale est en vacances, le palais est ouvert au public – y compris la collection d'art et le jardin royal.

Tras varias reformas, el palacio del Duque de Buckingham construido en 1703, se convirtió en 1837 en la residencia oficial de los reyes. En agosto y septiembre, cuando la familia real está de vacaciones, el palacio se abre al público, incluida su colección de arte y los jardines reales.

Nel 1837 il palazzo del duca di Buckingham, costruito nel 1703 e più volte ristrutturato, divenne la residenza ufficiale dei sovrani. In agosto e settembre, quando la famiglia reale è in vacanza, il palazzo viene aperto al pubblico ed è possibile ammirare tra l'altro la collezione d'arte e i giardini reali.

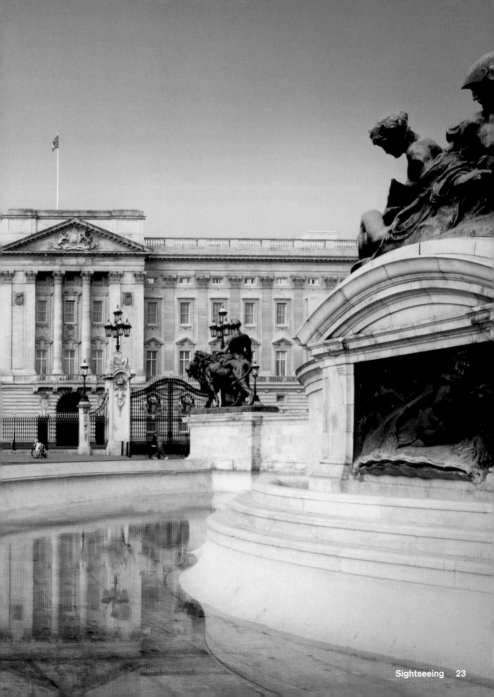

Westminster Cathedral

42 Francis Street
London
SW1P 1QW
Westminster
Phone: +44 / 20 / 77 98 90 55
www.westminstercathedral.org.uk

Opening hours: Daily opens shortly before the first Mass of the day to 7 pm, Sun closes after the 7 pm Mass
Tube: Victoria
Map: No. 58

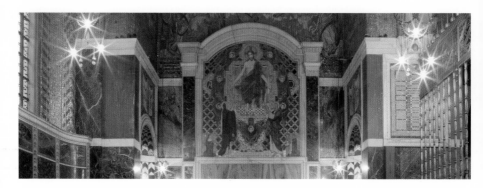

Close to Victoria Station, Great Britain's largest Catholic church was built by John Francis Bentley in 1903 in the early-Christian Byzantine style, which is unusual for England. The Oriental appearance with domes and balconies is reminiscent of a mosque. The colorful mosaics of the interior are fascinating.

La plus grande église catholique du Royaume-Uni a été construite en 1903 près de la Victoria Station par John Francis Bentley dans le style byzantin de l'Eglise primitive, peu commun en Angleterre. L'aspect oriental avec ses coupoles et balcons rappelle une mosquée, à l'intérieur, il y a de magnifiques mosaïques colorées.

La mayor iglesia católica de Gran Bretaña fue construida en 1903 por John Francis Bentley cerca de la estación Victoria, en un estilo paleocristiano-bizantino atípico en Inglaterra. Su apariencia oriental, con cúpulas y balcones, recuerda a una mezquita. En su interior resultan fascinantes los mosaicos multicolores.

Nel 1903 John Francis Bentley costruì la maggiore chiesa cattolica di Gran Bretagna accanto alla Victoria Station, in uno stile paleocristiano-bizantino poco consueto a queste latitudini: il suo aspetto orientaleggiante con cupole e balconi ricorda più una moschea. All'interno affascinanti e variopinti mosaici.

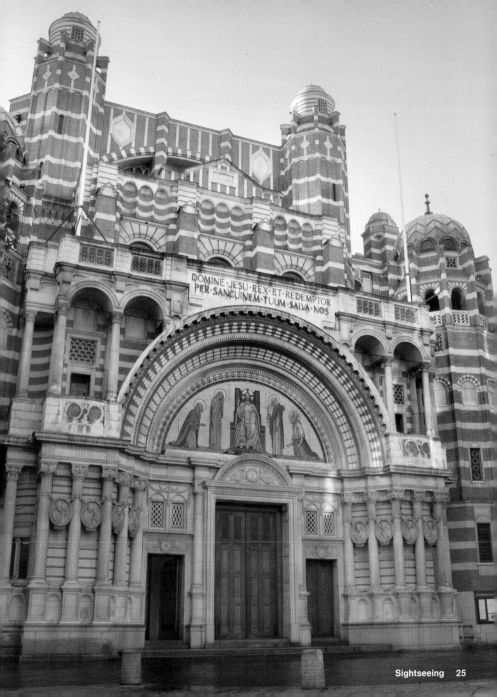

DOMINE · IESU · REX · ET · REDEMPTOR
PER · SANGUINEM · TUUM · SALVA · NOS

St Paul's Cathedral

The Chapter House
St Paul's Churchyard
London
EC4M 8AD
City of London
Phone: +44 / 20 / 72 36 41 28
www.stpauls.co.uk

Opening hours: Mon–Sat 8.30 am to 4 pm
Admission: £ 9.50, concessions £ 8.50, children 7–16 years £ 3.50, families (2 children, 2 adults) £ 22.50
Tube: St Paul's
Map: No. 47

Sir Christopher Wren built Europe's second-largest cathedral after the Great Fire of 1666. The view of London from the dome is sensational. In Whispering Gallery, the visitor's whisper resonates many times as an echo. On the ground level, the tombs of Nelson and Wellington are impressive.

La plus grande cathédrale de l'Europe a été érigée après le Grand Incendie de 1666 par Sir Christopher Wren. Depuis la coupole, la vue sur Londres est spectaculaire, et dans la « Galerie des Chuchotements », l'écho du chuchotement est répercuté plusieurs fois. Au rez-de-chaussée, il y a les tombeaux de Nelson et Wellington.

La segunda catedral más grande de Europa fue construida por Sir Christopher Wren tras el Gran Incendio de 1666. La vista de Londres desde la cúpula es sensacional, y en la Galería de los Susurros cada cuchicheo de los visitantes se amplifica indefinidamente. Los monumentos de Nelson y Wellington ubicados a nivel de suelo son impresionantes.

La seconda cattedrale più grande d'Europa fu eretta da Sir Christopher Wren nel 1666, dopo il Grande Incendio. La vista sulla città dalla cupola è sensazionale. Curiosa la Galleria dei Sussurri, dove ogni piccolo bisbiglio viene amplificato diverse volte. Maestosi i monumenti a Nelson e Wellington.

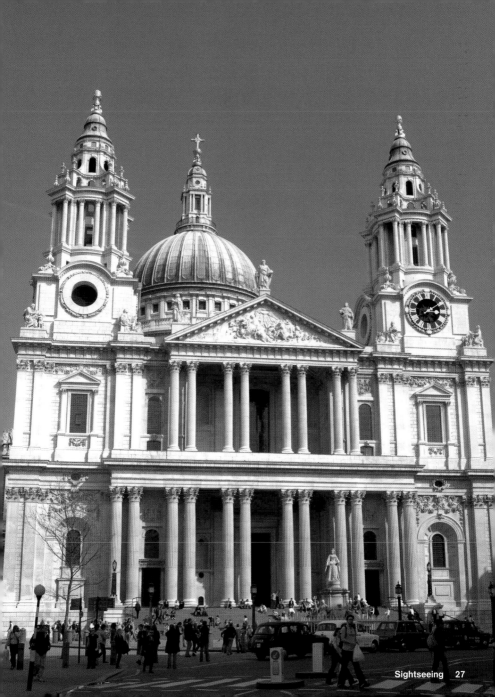

Tower of London

London
EC3N 4AB
Tower Hill
Phone: +44 / 870 / 7 56 60 60
www.hrp.org.uk

Opening hours: March–Oct Tue–Sat 9 am to 6 pm, Sun+Mon 10 am to 6 pm, Nov–Feb Tue–Sat 9 am to 5 pm, Sun+Mon 10 am to 5 pm
Admission: Adults £ 16, families £ 45, children 5–16 year £ 9.50, children (5 and under) free
Tube: Tower Hill
Map: No. 54

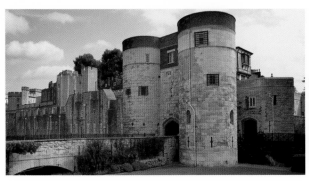

The Medieval tower fortress that was begun in 1078 has always been more than just a dungeon: It also served as an armory. Even today, the crown jewels such as the Imperial State Crown with its more than 3,000 gemstones are kept here—they are the main attraction of London's most-visited landmark.

La tour fortifiée médiévale, commencée en 1078, a toujours été plus qu'une oubliette : elle a aussi servi d'arsenal, et aujourd'hui encore, des joyaux sont conservés ici, comme la Couronne Impériale avec plus de 3 000 pierres précieuses – ce sont les attractions principales de cet endroit, le plus visité de Londres.

La torre-fortaleza medieval, cuya construcción comenzó en 1078, siempre ha sido más que una mazmorra: también ha hecho las funciones de arsenal, y aún hoy, se custodian aquí joyas como la Corona del Estado Imperial, con sus más de 3 000 piedras preciosas, la mayor atracción de lo que es el lugar más visitado de Londres.

La torre-fortezza medievale, iniziata nel 1078, è sempre stata molto di più che un carcere: è stata usata come arsenale, e ancora oggi vi sono custoditi i gioielli della corona, come la Corona Imperiale di Stato con le sue oltre 3 000 pietre preziose, principale attrazione del luogo più visitato di Londra.

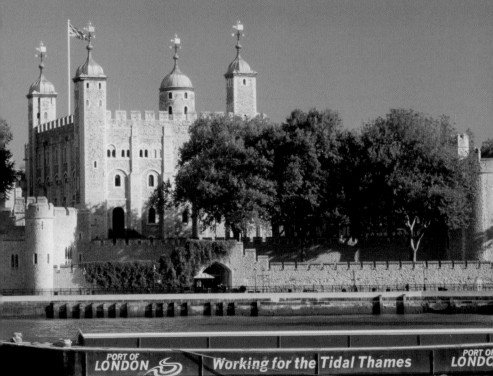

Tower Bridge

Tower Bridge Exhibition
Tower Bridge
London
SE1 2UP
Bermondsey
Phone: +44 / 20 / 74 03 37 61
www.towerbridge.org.uk

Opening hours: Exhibitions April–Sept daily 10 am to 6.30 pm,
Oct–March 9.30 am to 6 pm
Admission: £ 6, concessions £ 4.50, children 5–15 years £ 3,
children (5 and under) free
Tube: Tower Hill, London Bridge
Map: No. 53

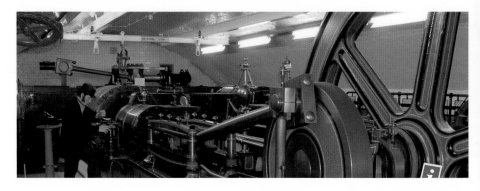

The bascule bridge, which was completed in 1894, is based on an ingenious idea by the city architect Horace Jones. The hydraulic mechanism is still the original one. Only the steam engines have been replaced by electric motors, but they can still be toured. The view from the walkways between the two towers is breathtaking.

Ce pont ouvrant, achevé en 1894, est basé sur une idée ingénieuse de l'architecte urbain Horace Jones. Le mécanisme hydraulique est toujours celui d'origine, seuls les moteurs à vapeur ont été remplacés par des moteurs électriques, mais on peut toujours les visiter. La vue depuis les couloirs entre les deux tours est spectaculaire.

Este puente levadizo, concebido a partir de la genial idea del arquitecto urbano Horace Jones, fue completado en 1894 y aún mantiene su mecanismo hidráulico original. También es posible visitar los antiguos motores de vapor, ahora substituidos por unos eléctricos. La vista desde el pasaje entre las dos torres es sobrecogedora.

Il ponte levatoio fu terminato nel 1894 e risale a una geniale idea dell'architetto di Stato Horace Jones. Il meccanismo idraulico è addirittura ancora l'originale. I vecchi motori a vapore sono stati sostituiti da altri elettrici, ma si possono comunque ancora osservare. La visuale dal passaggio tra le torri è mozzafiato.

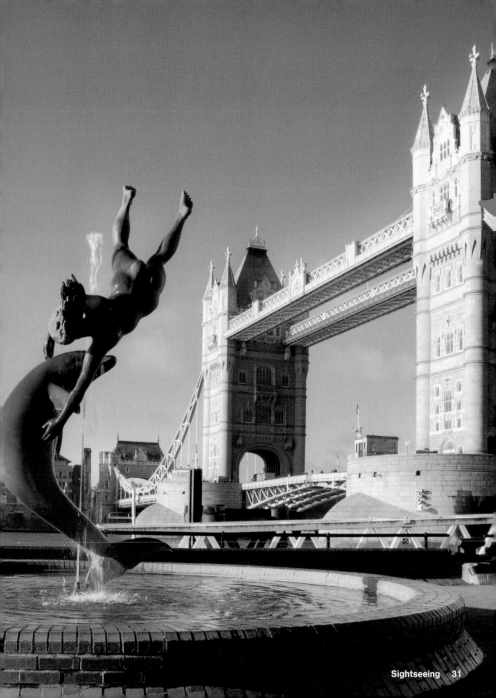

City Hall

The Queen's Walk
More London
London
SE1 2AA
Bermondsey
Phone: +44 / 20 / 79 83 40 00
www.london.gov.uk

Opening hours: Mon–Fri 8 am to 8 pm and on selected weekends
Tube: London Bridge, Tower Hill
Map: No. 11
Special note: Wheelchair accessible

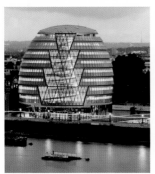

The prominent building by Lord Norman Foster is the workplace of London's mayor and headquarters of the Greater London Authority (GLA). Its shape reminds people of a giant egg and the sweeping spiral staircase on the inside is fascinating. The Scoop, an oval amphitheater, is located directly next to it.

Le bâtiment remarquable de Lord Norman Foster est le lieu de travail du maire de Londres et le siège de l'administration de la ville Greater London Authority (GLA). Sa forme rappelle un énorme œuf, à l'intérieur, il y a un grand escalier à vis. Directement à côté se trouve « The Scoop », un amphithéâtre ovale.

El característico edificio de Lord Norman Foster es el lugar de trabajo del alcalde y hospeda a la administración de la región de Gran Londres (GLA). Su forma recuerda a un huevo gigante, y en el interior se puede admirar la fascinante escalera saliente de caracol. Justo al lado, se encuentra el anfiteatro oval "The Scoop".

Il caratteristico edificio di Lord Norman Foster è la sede del municipio della città, e dell'amministrazione regionale della Grande Londra. La sua forma ricorda un gigantesco uovo, mentre all'interno troviamo un'affascinante scala a chiocciola rastremata. Di fianco al palazzo si trova l'anfiteatro ovale "The Scoop".

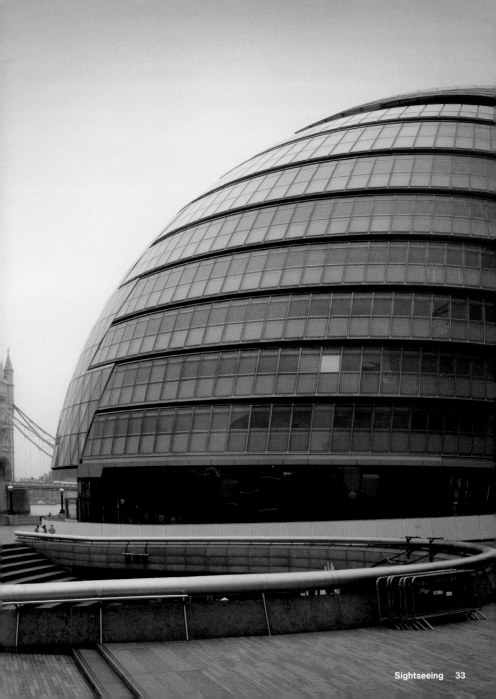

Culture
Museums Galleries Theaters Cinemas

London is considered one of the leading art metropolises. Above all, international modern art is on display at Tate Modern. Design also has a museum of its own. Tate Britain and the British Museum are more traditional. Admission to most of the state museums—with the exception of temporary exhibitions—is free. The money saved can be invested well in the extensive selection of music and theater that London has to offer.

Londres est connue comme une des principales métropoles de l'art. L'art moderne international est surtout exposé dans le Tate Modern, et le design a également son propre musée. Plus traditionnels: le Tate Britain et le British Museum. L'entrée dans la plupart des musées d'état – à l'exception des expositions temporaires – est gratuite. On peut très bien investir ses économies dans l'offre énorme de musique et de théâtres de Londres.

Londres es considerada una de las ciudades artísticas más importantes. El Arte Moderno Internacional se admira especialmente en Tate Modern, y el diseño cuenta también con su propio Museo. Los clásicos son el Tate Britain y el British Museum. En la mayoría de los museos estatales la entrada es gratuita, salvo para exposiciones itinerantes. Lo que se ahorra aquí se puede invertir en la enorme oferta musical y teatral de la ciudad.

Londra è considerata una delle principali città d'arte. Per l'arte moderna internazionale spicca il Tate Modern, e anche il design ha un suo museo riservato. Il Tate Britain e il British Museum sono più tradizionali. L'ingresso nel più importante museo nazionale è libero (tranne per le esposizioni speciali), e per … reinvestire il risparmio ci sono occasioni musicali e teatrali in abbondanza.

Left page: Tate Modern
Right page: Left stairway in the National Gallery, right Royal Albert Hall

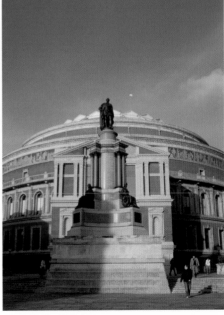

National Gallery

Trafalgar Square
London
WC2N 5DN
Covent Garden
Phone: +44 / 20 / 77 47 28 85
www.nationalgallery.org.uk

Opening hours: Daily 10 am to 6 pm, Wed to 9 pm
Admission: Free, except special exhibitions
Tube: Leicester Square, Charing Cross
Map: No. 35

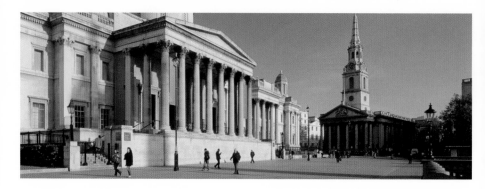

The National Gallery of Great Britain on the north side of Trafalgar Square has one of the most impressive collections of Western European art, including showpieces like Claude Monet's "The Water-Lily Pond," Sandro Botticelli's "Venus and Mars," Vincent van Gogh's "Chair," or Titian's "Bacchus and Ariadne."

La National Gallery de Grande-Bretagne sur le côté nord de Trafalgar Square possède une des collections d'art d'Europe de l'ouest les plus impressionnantes, dont des trésors comme le « Bassin aux Nymphéas » de Claude Monet, « Venus et Mars » de Sandro Botticelli, « Chaise avec Pipe » de Vincent van Gogh et « Bacchus et Ariadne » de Titien.

La galería nacional de Gran Bretaña, situada en el lado norte de Trafalgar Square, posee una de las más impresionante colecciones de arte europeo, que incluye obras maestras como "Lirios de Agua" de Monet, "Venus y Marte" de Botticelli, "Silla con Pipa" de van Gogh y "Baco y Ariadna" de Tiziano.

La Galleria Nazionale britannica, sul lato nord di Trafalgar Square, ospita una delle più impressionanti collezioni d'arte dell'Europa Occidentale, tra cui delle autentiche chicche come i "Gigli d'Acqua" di Claude Monet, "Venere e Marte" di Sandro Botticelli, "Sedia con Pipa" di Vincent van Gogh e "Bacco e Arianna" di Tiziano.

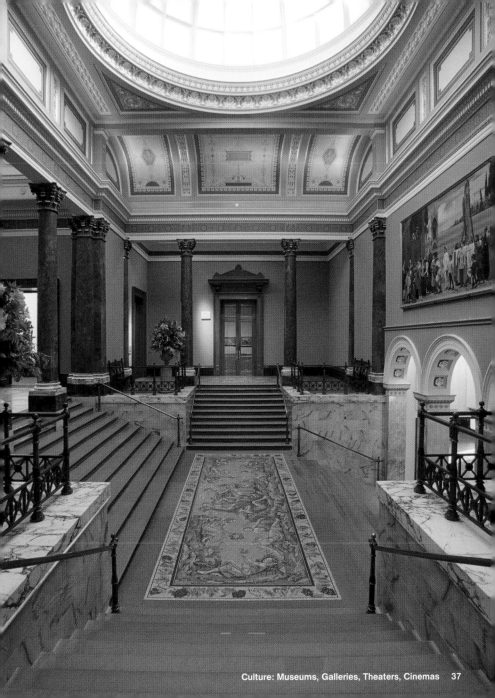

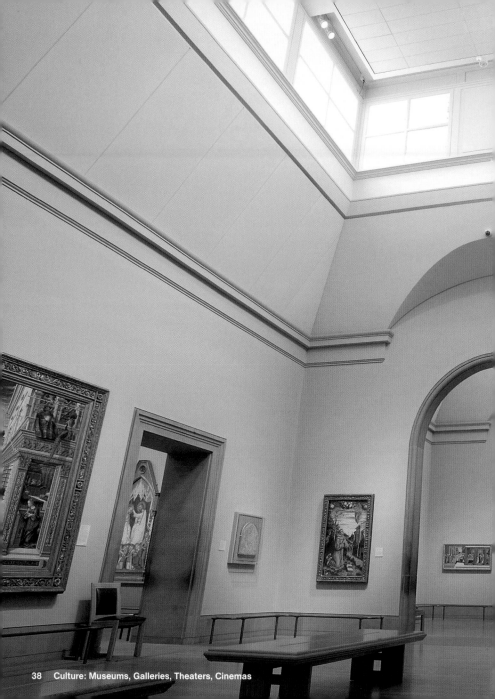

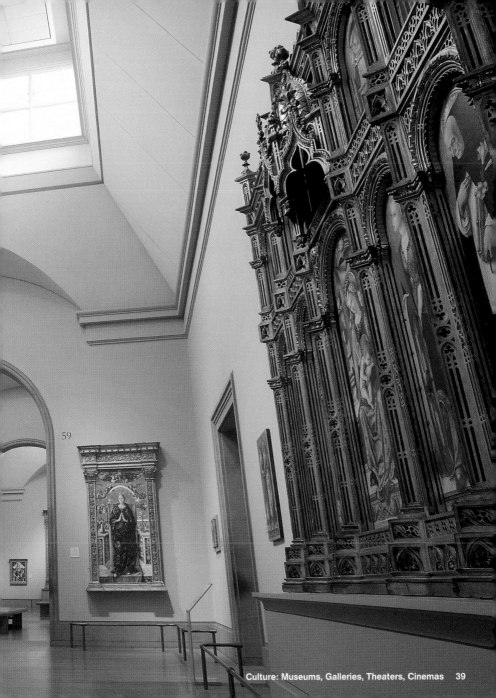

Royal Opera House

Bow Street
London
WC2E 9DD
Covent Garden
Phone: +44 / 20 / 72 40 12 00
www.royaloperahouse.org

Opening hours: Guided Tours Mon–Sat from 10.30 am three times a day
Admission: Guided tours £ 9, performances see website
Ticket service: +44 / 20 / 73 04 40 00
Tube: Covent Garden
Map: No. 44
Editor's tip: Seats are sold from 10 am on the day of the performance to personal callers at the Box Office.

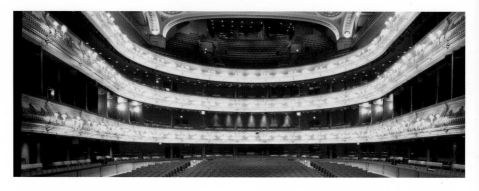

The Royal Opera House, which is also the home of the Royal Ballet, only stages operas, concerts, and ballet performances of international standing. It's also possible to take a look behind the scenes here. In addition, there are cafés and restaurants, as well as tea dances, wine-tasting, and exhibitions.

Dans l'opéra royal qui héberge aussi le ballet royal, on ne donne que des opéras, concerts et ballets d'un niveau international. Ici, on peut aussi regarder dans les coulisses. De plus, il y a des cafés et des restaurants, des thés dansants, des dégustations de vin et des expositions.

En el Palacio Real de la Ópera, que alberga también al Royal Ballet, se representan sólo óperas, conciertos y ballet de rango internacional. También es posible echar una ojeada detrás del telón. A ello se suman cafés y restaurantes, tés danzantes, degustaciones de vinos y exposiciones.

Nel teatro reale dell'opera, che è anche la sede del balletto reale, si rappresentano esclusivamente opere, concerti e balletti di rango internazionale. È permesso sbirciare dietro le quinte. L'area è attrezzata con bar e ristoranti, e vi si tengono tè danzanti, degustazioni di vino e altre manifestazioni.

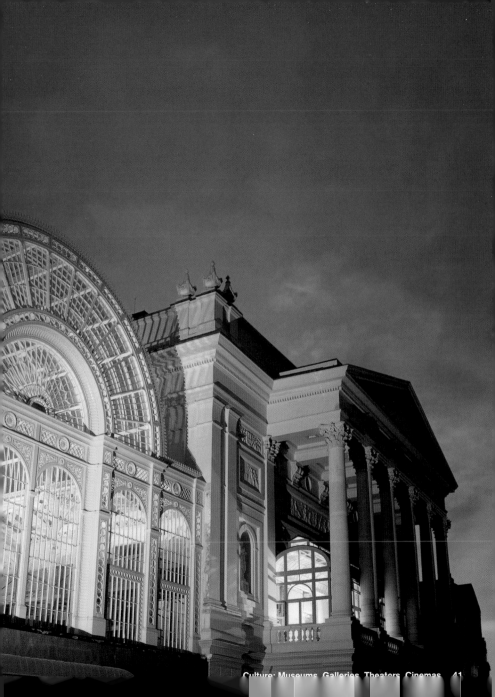

British Museum

Great Russell Street
London
WC1B 3DG
Bloomsbury
Phone: +44 / 20 / 73 23 80 00
www.thebritishmuseum.ac.uk

Opening hours: Great Court Sun–Wed 9 am to 6 pm, Thu–Sat to 11 pm, galleries Sat–Wed 10 am to 5.30 pm, selected galleries and special exhibitions Thu+Fri to 8.30 pm
Tube: Holborn, Tottenham Court Road, Russell Square, Goodge Street
Map: No. 7

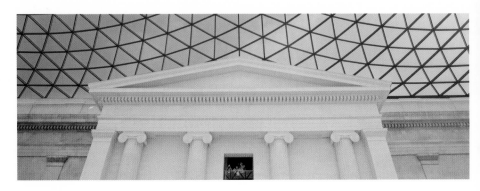

The building, which belongs to the world's biggest museum for culture and history, has a collection of more than seven million objects. Among them are a statue from the Easter Islands and the first known image of Christ. Its inner courtyard is one of the largest covered plazas in Europe with a ceiling made of 1,656 glass triangles.

La maison, qui est un des plus grands musées pour la culture et l'histoire au monde, a une collection de plus de sept millions d'objets, dont une statue des Iles de Pâques et la première image connue du Christ. Sa cour intérieure est la plus grande place couverte de l'Europe, avec un toit de 1 656 triangles de verre.

Esta institución pertenece al mayor museo de arte e historia del mundo, y posee una colección de más de siete millones de ejemplares, entre los cuales se encuentra una estatua de la Isla de Pascua y la primera imagen de Cristo conocida. Su amplio patio interior es la mayor plaza cubierta de Europa, con un tejado de 1 656 triángulos de cristal.

Nientemeno che il più grande museo al mondo per la cultura e la storia, con oltre sette milioni di pezzi in esposizione, tra i quali una scultura dell'Isola di Pasqua e la prima immagine di Cristo conosciuta. Il cortile interno è la piazza coperta più grande d'Europa, con un tetto di 1 656 triangoli in vetro.

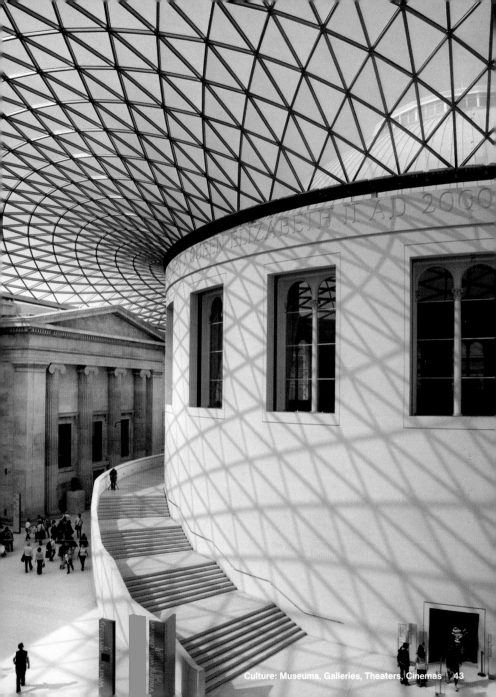

Hayward Gallery

Southbank Centre
Belvedere Road
London
SE1 8XX
Southwark
Phone: +44 / 20 / 79 21 08 13
www.southbankcentre.co.uk

Opening hours: Daily from 10 am to 6 pm, Tue+Wed to 8 pm,
Fri to 9 pm
Admission: Approx. £ 8, price varies depending on the exhibition
Ticket service: +44 / 870 / 1 69 10 00
Tube: Waterloo, Embankment, Charing Cross
Map: No. 24

Londoners have divided opinions about the appearance of the solid concrete building, which was completed in 1968. But they do agree that the gallery's rough and basic look is an excellent backdrop for the various spectacular exhibitions of contemporary art—with up to four shown here every year.

Les opinions sur l'aspect de ce bâtiment massif en béton, achevé en 1968, sont partagées. Mais on s'accorde à dire que l'aspect rugueux de la galerie constitue un excellent cadre pour les spectaculaires expositions temporaires d'art contemporain – il y en a jusqu'à cinq par an.

Los londinenses difieren en opinión sobre esta construcción en hormigón macizo, finalizada en 1968. En lo que sí se está de acuerdo es en que la tosca fisonomía de la galería resulta un excelente escenario para las espectaculares exposiciones de arte contemporáneo, hasta cuartro al año, que tienen lugar aquí.

I londinesi hanno opinioni contrastanti sulla massiccia costruzione in cemento, terminata nel 1968, ma una cosa è certa: la ruvida fisionomia della galleria è uno scenario eccezionale per le svariate e spettacolari esposizioni di arte contemporanea che qui si allestiscono, fino a quattro all'anno.

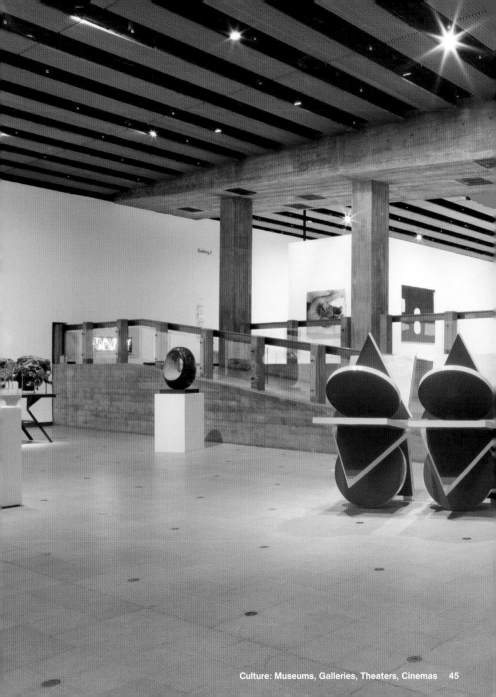

National Theatre

South Bank
London
SE1 9PX
Southwark
Phone: +44 / 20 / 74 52 34 00
www.nationaltheatre.org.uk

Opening hours: Mon–Sat 10 am to 11 pm
Admission: Guided tours £ 5, performances see website
Ticketservice: +44 / 20 / 74 52 30 00
Tube: Waterloo, Southwark, Embankment
Map: No. 36

The National Theatre—which Prince Charles once called a "nuclear power station" because of its concrete architecture—houses three stages. The program includes both classics and modern plays. In the foyer, which is open to the public, live music sets the mood for the performances.

Le théâtre national, que le Prince Charles a qualifié un jour de « centrale nucléaire » à cause de son architecture en béton, contient trois scènes. Le répertoire comporte aussi bien des pièces classiques que modernes. Dans le foyer, ouvert au public, il y a de la musique « live » pour créer une ambiance avant les représentations.

El Teatro Nacional, que por su arquitectura el Príncipe Carlos en una ocasión ha llamado "la Central Nuclear", cuenta con tres escenarios. Su repertorio abarca piezas tanto clásicas como modernas. En el vestíbulo, accesible al público, se escucha música en vivo para acompañar la función.

Soprannominato "centrale atomica" dal Principe Carlo per la sua architettura in cemento, il Teatro Nazionale contiene tre palcoscenici. Il repertorio abbraccia pièce classiche e moderne, e nel foyer, di pubblico accesso, si ascolta musica dal vivo a tema con le rappresentazioni.

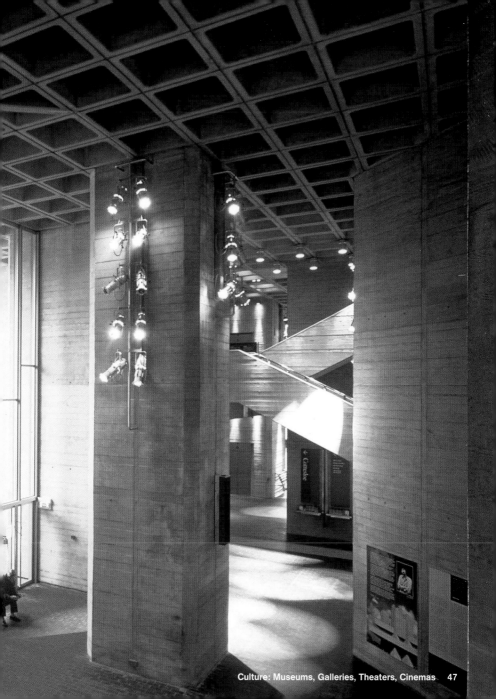

Shakespeare's Globe Theatre

21 New Globe Walk
Bankside
London
SE1 9DT
Southwark
Phone: +44 / 20 / 79 02 14 00
www.shakespeares-globe.org

Opening hours: Theater May–Oct, guided tours all year round
Admission: Guided tours £ 9, Theater see website
Ticket service: +44 / 20 / 74 01 99 19
Tube: Mansion House, Cannon Street, London Bridge,
Southwark, Blackfriars
Map: No. 45

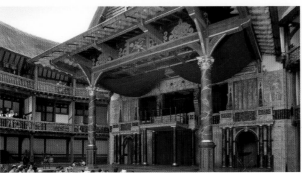

Every summer, the Globe Theatre offers a program with plays by Shakespeare and his contemporaries. The theater, which opened in 1997, has been modeled as accurately as possible after the Elizabethan original of 1599: The circular audience section is in the open air. During the wintertime, there are no performances so the arts and crafts Frost Fairs take place here.

Chaque été, le Globe Theatre offre des représentations de pièces de Shakespeare et de ses contemporains. Le théâtre, ouvert en 1997, est une copie fidèle de l'original élisabéthain de 1599 : les gradins des spectateurs se trouvent en plein air. Pendant l'hiver, les « Frost Fairs », foires d'art et d'artisanat, sont organisées ici.

Todos los veranos el Globe Theatre ofrece un programa con piezas de Shakespeare y obras contemporáneas. El teatro fue inaugurado en 1997 y reproduce fielmente la atmósfera isabelina original de 1599. El patio carece de techo. En invierno no tienen lugar representaciones sino ferias de artesanía "Frost Fairs".

Ogni estate il Globe Theatre offre un programma di opere da Shakespeare ai giorni nostri. Aperto nel 1997, è per quanto possibile fedele allo spirito dell'originale elisabettiano del 1599, ad esempio gli spettatori si accomodano sotto il cielo aperto. D'inverno le rappresentazioni lasciano spazio alle fiere d'artigianato "Frost Fairs".

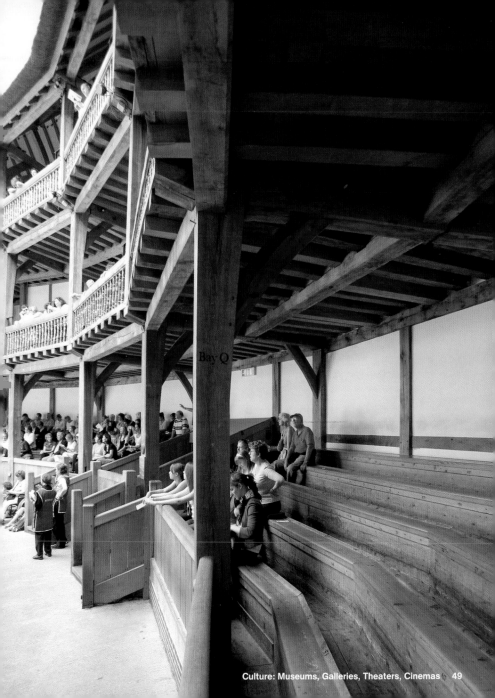

Bay Q

Tate Modern

Bankside
London
SE1 9TG
Southwark
Phone: +44 / 20 / 78 87 88 88
www.tate.org.uk

Opening hours: Sun–Thu 10 am to 6 pm, Fri+Sat to 10 pm
Admission: Free, except special exhibition
Tube: Southwark, Blackfriars
Map: No. 49

The Tate's international collection of modern art found its new home in a former power station in the year 2000. The one-time turbine hall serves as the entrance area and showroom for large sculptures. The boiler house holds the gallery rooms, and the glass penthouse with its café provides a great view across the city.

La collection internationale d'art moderne de la « Tate » a trouvé son nouveau domicile en 2000 dans cette ancienne centrale électrique. L'ancienne salle des turbines sert de foyer et de salle d'exposition pour les grandes sculptures. La chaufferie héberge les salles d'exposition et le café sur la terrasse avec sa verrière offre une vue superbe sur la cité.

Lo que en su día fue una central eléctrica, en el año 2000 pasó a albergar la colección internacional de Arte Moderno del "Tate". La sala de turbinas sirve de área de acceso y espacio de exposiciones para esculturas de gran envergadura. La sala de calderas alberga la galería, y desde el café de su terraza acristalada se disfruta de una vista magnífica de la ciudad.

Nel 2000, la collezione internazionale d'arte moderna del Tate ha trovato la sua nuova casa in una ex centrale elettrica. L'antica sala turbine funge ora da atrio d'ingresso e area di esposizione per le sculture più grosse, mentre la ex sala caldaie ospita la galleria vera e propria, e dall'attico in vetro con caffè si gode una fantastica visuale della City.

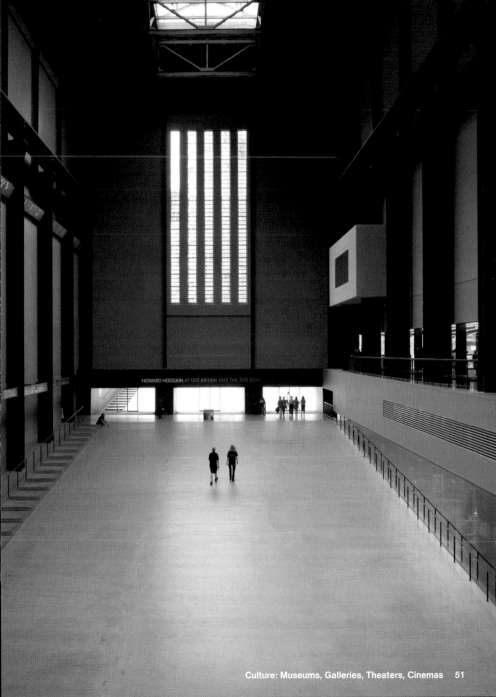

In the image: HOWARD HODGKIN AT TATE BRITAIN TAKE THE TATE BOAT

Tate Britain

Millbank
London
SW1P 4RG
Pimlico
Phone: +44 / 20 / 78 87 88 88
www.tate.org.uk

Opening hours: Daily 10 am to 5.50 pm, last admission at 5 pm, first Friday of each month to 10 pm
Admission: Free, except special exhibition
Tube: Pimlico, Vauxhall, Westminster
Map: No. 48

Since the international modern art collection moved out, the former Tate Gallery in the classical building in Pimlico houses the largest collection of British art from the 16th century to the present. The building was constructed in 1897. Especially worth seeing: William Turner's complete estate in the Clore Gallery, which was built in 1987.

Après le déménagement de l'art moderne international, l'ancienne « Tate Gallery » héberge, dans ce bâtiment classique à Pimlico, construit en 1897, la plus grande collection d'art britannique du XVIe siècle jusqu'à aujourd'hui. Particulièrement intéressant : l'héritage complet de William Turner, dans la Clore Gallery, l'annexe construite en 1987.

Desde el traslado de la colección internacional de Arte Moderno, la antigua "Tate Gallery" expone en un edificio neoclásico en Pimlico construido en 1897, la mayor colección de arte británico desde el siglo XVI hasta hoy. El legado completo de William Turner en la Clore Gallery, construida en 1987, resulta de especial interés.

Dopo la scissione della Modern, la ex Tate Gallery espone la sua collezione in un edificio neoclassico in Pimlico, costruito nel 1897. La sua è la maggiore collezione di arte britannica dal secolo XVI a oggi. Di particolare interesse l'eredità completa di William Turner nella Clore Gallery, aperta nel 1987.

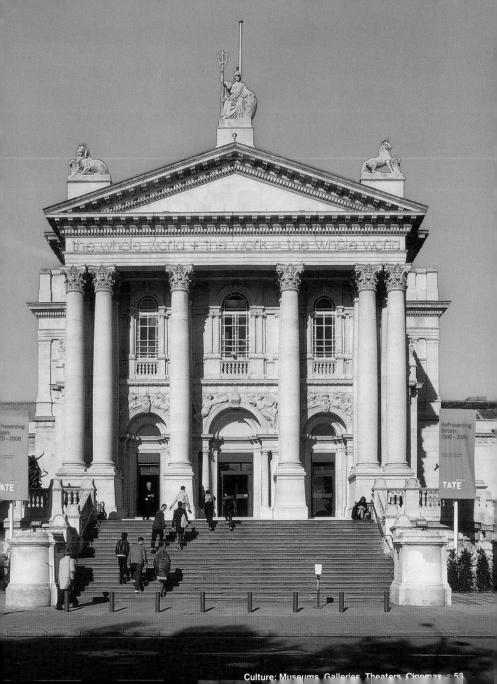

Royal Albert Hall

Kensington Gore
London
SW7 2AP
South Kensington
Phone: +44 / 20 / 75 89 32 03
www.royalalberthall.com

Opening hours: Fri–Tue tours in English
Admission: Tours £ 7.50, family ticket £ 25, performances see website
Tube: High Street Kensington, Knightsbridge
Map: No. 43
Editor's tip: On a guided tour in the daytime you might catch a glimpse of the rehearsal for a performance.

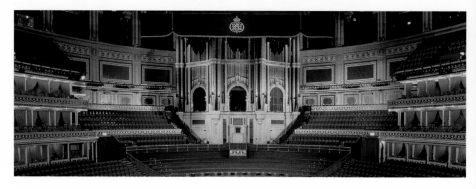

From the outside, the Royal Albert Hall looks like a sugar-frosted cake; on the inside, it is a dream in red-gold. Built in 1871 according to an idea by Queen Victoria's German husband Prince Albert, it offers concerts of classical music—such as the famous Last Night of the Proms—in addition to pop and sports events.

Vu de l'extérieur, le Royal Albert Hall ressemble à une tarte couverte de glaçage en sucre ; à l'intérieur, c'est un rêve en rouge et or. Construit en 1871 sur une idée du Prince Albert, le mari allemand de la Reine Victoria, on y donne des concerts classiques – comme la fameuse « Last Night of the Proms » –, et des événements sportifs et des concerts pop.

Desde el exterior el Royal Albert Hall parece una tarta recubierta de azúcar, su interior es sin embargo como un sueño en rojo y oro. Fue construido en 1871 según una idea del Príncipe Alberto, el esposo alemán de la Reina Victoria, y aquí tienen lugar conciertos clásicos como la famosa "Last Night of the Proms" además de eventos deportivos y de música pop.

Dall'esterno la Royal Albert Hall ricorda una torta spruzzata di zucchero, dall'interno è come un sogno di rosso e oro. Edificata nel 1871 su un'idea del Principe Alberto, il consorte tedesco della Regina Vittoria, vi si tengono concerti classici come la famosa "Last Night of the Proms", così come eventi sportivi e concerti rock.

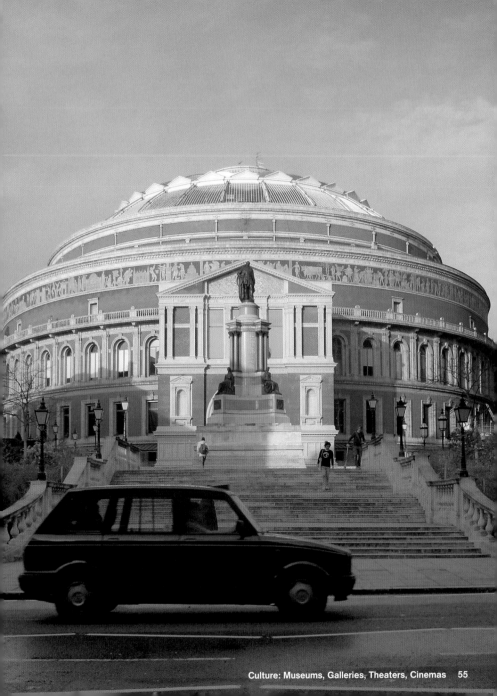

Design Museum

Shad Thames
London
SE1 2YD
Bermondsey
Phone: +44 / 870 / 8 33 99 55
www.designmuseum.org

Opening hours: Daily 10 am to 5.45 pm
Admission: £ 7, concessions £ 4, children (12 and under) free
Ticket service: www.ticketweb.co.uk
Tube: London Bridge, Tower Hill
Map: No. 18

Even the façade of this museum, founded by
Sir Terence Conran in 1989 near the Tower
Bridge, is fascinating because of its elegance.
The interior has clean lines and a sense of
spaciousness. Timeless classic design is
presented here—from cars to telephones to
washers, and from Mackintosh to Le Corbusier.

De loin déjà, la façade du musée, fondé en
1989 par Sir Terence Conran, près du Tower
Bridge, séduit par son élégance. L'intérieur,
vaste et sans décor, présente du design
classique – des voitures aux machines à laver
en passant par des téléphones, et de Mackin-
tosh à Le Corbusier.

Ya desde el exterior la fachada del museo
fundado en 1989 por Sir Terence Conran cerca
del Tower Bridge destaca por su elegancia. En
su interior, de carácter esencial y espacioso, se
presentan obras inmortales de diseño, desde
coches o teléfonos a lavadoras, pasando por
Macintosh y hasta Le Corbusier.

Fondato nel 1989 da Sir Terence Conran
accanto al Tower Bridge, già dall'esterno il
museo emana eleganza e buon gusto.
L'interno è altrettanto curato, spazioso e senza
fronzoli, e presenta design classico senza età,
dall'automobile al telefono alla lavatrice, dai
MacIntosh a Le Corbusier.

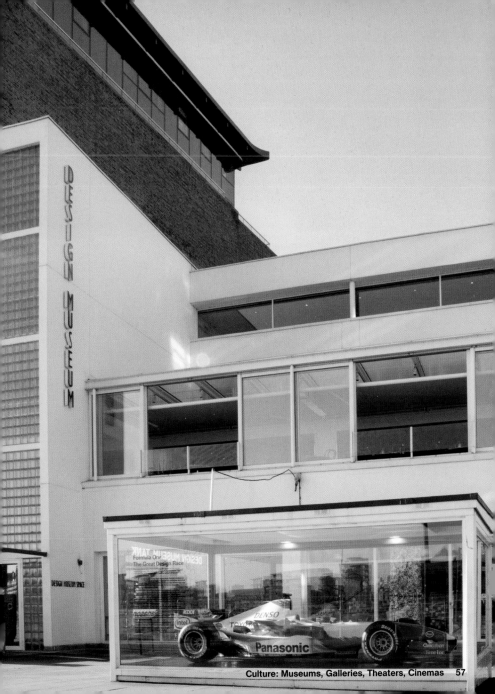

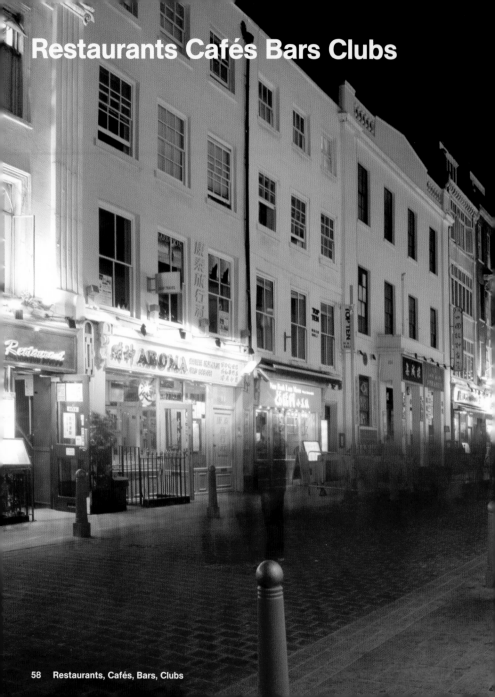

Restaurants Cafés Bars Clubs

Be sure to forget any prejudices you may have against British cuisine: The cosmopolitanism of the capital's residents and their willingness to try something new is reflected in the culinary scene. Restaurants of every nationality can be found in all of London—often with outstanding quality, but rather expensive. The pubs with their small meals accompanied by perfectly cooled beer are a good and cheaper alternative.

On peut assurément oublier ses préjugés sur la cuisine britannique : l'ouverture au monde et la créativité des métropolitains se reflètent dans l'offre culinaire. Partout à Londres, il y a des restaurants de toutes nationalités – souvent d'une excellente qualité, mais relativement chers. Une bonne alternative à prix modérés sont les pubs avec leurs petits repas accompagnés d'une bière bien fraîche.

De los tópicos sobre la cocina británica hay que olvidarse tranquilamente: la apertura al mundo y las ganas de experimentar de sus habitantes se reflejan en la oferta culinaria. En toda Londres se encuentran restaurantes de todas la nacionalidades y, a menudo, de excelente calidad … pero nada baratos. Los pubs constituyen una excelente alternativa con sus platos pequeños y cervezas deliciosamente frías.

I luoghi comuni sulla cucina inglese si possono tranquillamente dimenticare: l'apertura al mondo e la libertà espressiva dei capitolini si rispecchia nell'offerta culinaria. In tutta Londra si trovano ristoranti di tutte le nazionalità, spesso di qualità eccellente, ma non proprio economici. Una valida alternativa sono i pub con i loro piatti più alla mano e le loro birre fresche al punto giusto.

Left page: Chinatown in Soho
Right page: Left mo*vida, right Automat

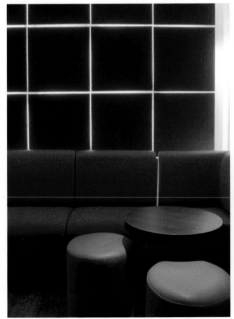
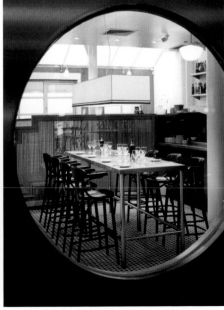

Automat

33 Dover Street
London
W1S 4NF
Mayfair
Phone: +44 / 20 / 74 99 30 33
www.automat-london.com

Opening hours: Breakfast 7 am to 11 am, lunch daily noon to 3 pm, dinner Mon–Sat 6 pm to 11 pm, brasserie Mon–Fri noon to 1 am, Sun to midnight, brunch Sat+Sun 11 am to 4 pm
Prices: Average price entree £ 14
Cuisine: North American
Tube: Green Park
Map: No. 1

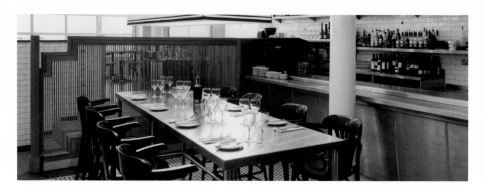

Despite its name, the Automat is not a vending-machine restaurant but a classic American diner. The food is also traditional American and so good that former President Bill Clinton with his entourage tried every single dish on the menu during a visit to London.

Malgré son nom, l'Automat n'est pas un restaurant à pièces, mais un dîner américain classique. Les repas aussi sont américains traditionnels et si bons que, lors d'une visite à Londres avec son entourage, l'ex-président Bill Clinton a goûté tous les plats de la carte.

A pesar de su nombre, el Automat no es un restaurante autoservicio, sino un clásico diner Americano; igual que su comida, tradicional-mente americana y tan buena, que incluso el ex presidente de Estados Unidos Bill Clinton, en una visita a Londres con su séquito, probó cada uno de los platos del menú.

Nonostante il nome, l'Automat non è un ristorante a gettoni, ma un classico diner americano. La cucina è dello stesso genere, e così apprezzata che una volta l'ex presidente degli USA Bill Clinton, in visita a Londra con tutto il seguito, volle assaggiare ogni singolo piatto del menu.

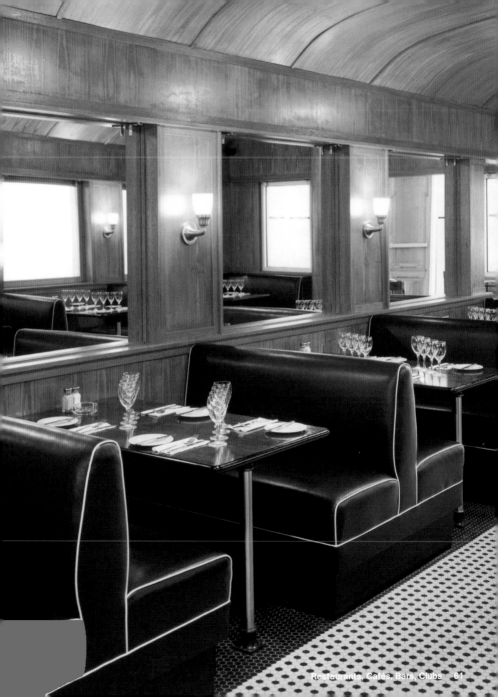

Sketch

9 Conduit Street
London
W1S 2XG
Mayfair
Phone: +44 / 870 / 7 77 44 88
www.sketch.uk.com

Opening hours: The Gallery Mon–Sat 7 pm to 2 am;
The Lecture Room & Library Tue–Fri noon to 2.30 pm, Tue–Sat
6.30 pm to midnight
Prices: The Gallery average price entree £ 40, The Lecture
Room & Library average price entree £ 90
Cuisine: New French
Tube: Oxford Circus
Map: No. 46

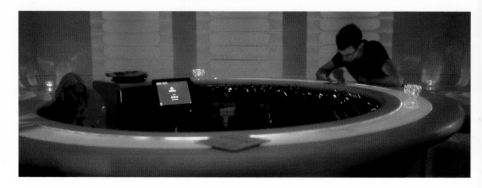

Award-winning chef Pierre Gagnaire and his design team have transformed a historic town house into a first-class temple of gastronomy—with restaurants, bars, a tearoom, and a gallery. Instead of dining à la carte, you can also select the "economical" lunch menu at a fixed price of about £ 42. The cuisine is excellent, and the design is worth seeing.

Le chef étoilé Pierre Gagnaire et son équipe de designers ont transformé un bâtiment urbain historique en temple de la gastronomie haut de gamme, avec des restaurants, bars, salon de thé et galerie. Au lieu de manger à la carte, on peut aussi prendre le menu « économique » du déjeuner fixé à quelque 42 £. La cuisine est excellente, le design vaut la visite.

El célebre cocinero Pierre Gagnaire y su equipo de creativos han transformado una histórica casa de ciudad en un templo gastronómico de primera calidad, con restaurantes, bares, salas de té y galerías. Además que comer a la carta, es posible elegir el "conveniente" menú del día por unas 42 libras. Tanto la comida como el diseño son excelentes.

Il celebre cuoco Pierre Gagnaire e il suo team di creativi hanno trasformato uno storico palazzo in un tempio della gastronomia di prima qualità, con ristoranti, bar, sala da tè e galleria. Oltre a ordinare à la carte, a pranzo è possibile scegliere il "conveniente" menu a prezzo fisso, sulle 42 sterline. La cucina è eccellente, il design da non perdere.

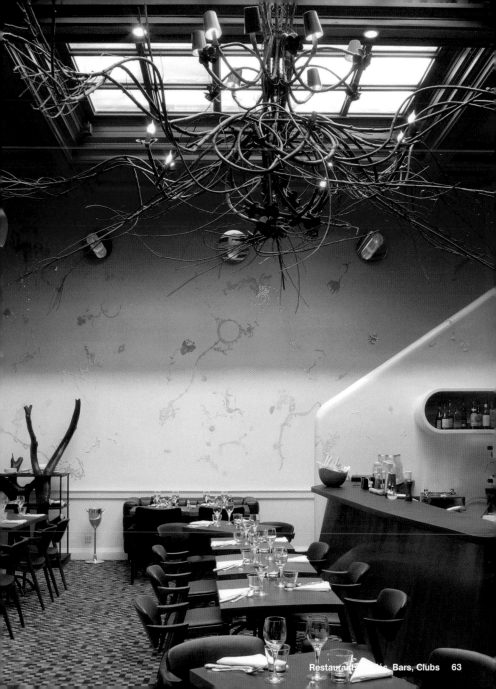

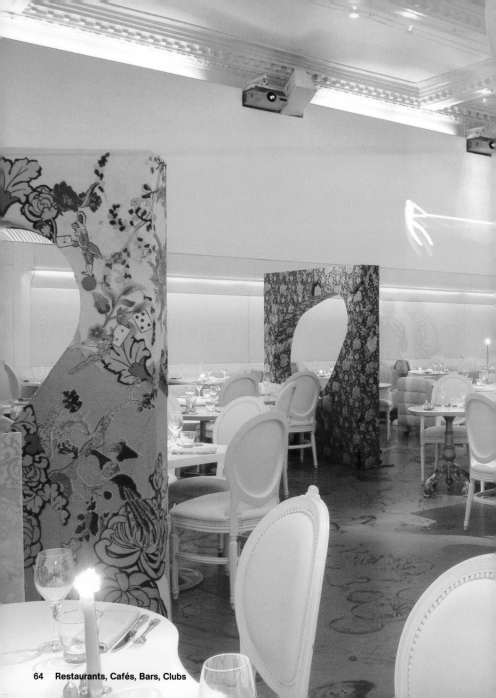

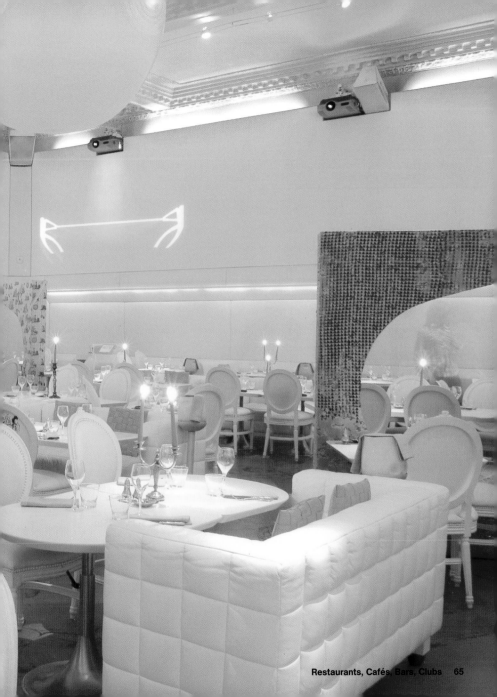

mo*vida

8–9 Argyll Street
London
W1F 7TF
Soho
Phone: +44 / 20 / 77 34 57 76
www.movida-club.com

Opening hours: Wed–Sat 8 pm to 3 am
Prices: Average price entree £ 35
Cuisine: French, Italian, English
Tube: Oxford Circus
Map: No. 33

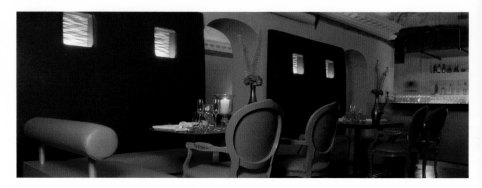

The mo*vida in the vaults of the Palladium Theater has been voted London's best club. It has a steady stream of celebrities like Scarlett Johansson or Bryan Ferry. The restaurant under the management of Samy Sass offers an exquisite fusion of French, English, and Italian cuisine.

Le mo*vida, dans la cave voûtée du Palladium Theater, a été désigné meilleur club de Londres. Il est assidûment fréquenté par des vedettes comme Scarlett Johansson ou Bryan Ferry. Le restaurant, sous la houlette de Samy Sass, offre un mélange exquis de cuisine française, anglaise et italienne.

El mo*vida, ubicado bajo las bóvedas del teatro Palladium, ha obtenido la distinción de mejor club de Londres. Por aquí se dejan ver personajes famosos como Scarlett Johansson o Bryan Ferry. El restaurante, dirigido por Samy Sass, ofrece una exquisita fusión de cocina francesa, inglesa e italiana.

Compreso nella cupola del Palladium Theater, il mo*vida è stato in passato premiato come miglior club di Londra. Gestito da Samy Sass, il ristorante offre uno squisito mix di cucina francese, inglese e italiana, e non è raro imbattersi in celebrità come Scarlett Johansson o Bryan Ferry.

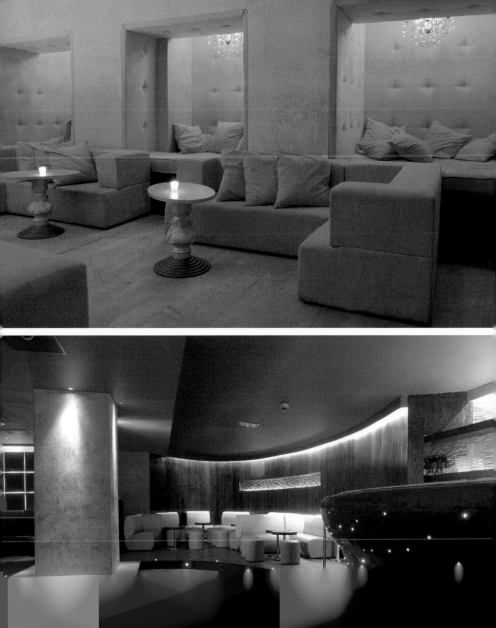

Yauatcha

15–17 Broadwick Street
London
W1F 0DL
Soho
Phone: +44 / 20 / 74 94 88 88

Opening hours: Teahouse daily noon to 11.45 pm, Sun to 10.45 pm, Dim-Sum restaurant daily noon to 2.30 pm, 5 pm to 11.45 pm, Sun to 10.45 pm
Prices: Average price entree £ 20
Cuisine: Chinese
Tube: Piccadilly Circus
Map: No. 59

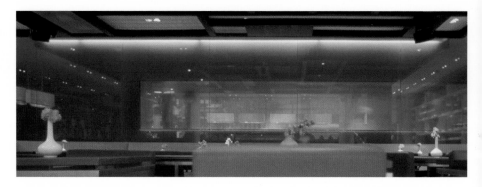

In London's best dim-sum restaurant, designed by Christian Liagre, a starry sky stretches above the tables and the bar consists of an aquarium full of exotic fish. You will feel like you are on a spaceship in the tearoom. Time and again, Michelin-Star recipient Cheong Wah Soon enthuses the culinary critics.

Dans le meilleur restaurant Dim-Sum de Londres, conçu par Christian Liagre, un ciel étoilé s'étend au-dessus des tables et le bar consiste en un aquarium plein de poissons exotiques. Dans le salon de thé, on se croirait dans un vaisseau spatial. Cheong Wah Soon, chef étoilé du Michelin, fascine encore et toujours les critiques gastronomiques.

En el mejor restaurante Dim Sum de Londres, diseñado por Christian Liagre, un cielo estrellado cubre las mesas, el bar es un acuario repleto de peces exóticos, y la sala de té crea la ilusión de una astronave. Cheong Wah Soon, titular de la estrella Michelin, no deja de fascinar a los críticos con sus continuas novedades.

Nel miglior ristorante Dim Sum di Londra, progettato da Christian Liagre, sopra ai tavoli si stende un cielo stellato, il bar è un acquario di pesci esotici, e la sala da tè richiama alla mente un'astronave. Il proprietario Cheong Wah Soon, premiato con la stella Michelin, trova sempre il modo di entusiasmare i critici con le sue novità.

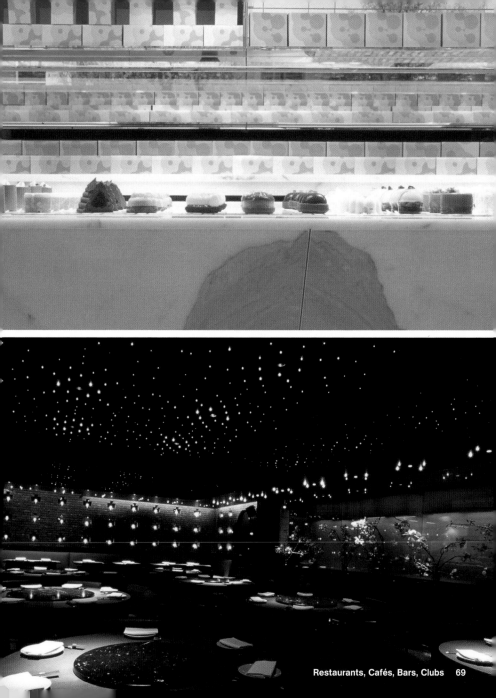

Moro

34–36 Exmouth Market
London
EC1R 4QE
Finsbury
Phone: +44 / 20 / 78 33 83 36
www.moro.co.uk

Opening hours: Mon–Sat 12.30 pm to 2.30 pm, 7 pm to 10.30 pm, tapas served all day
Prices: Average price entrée £ 17.50
Cuisine: Spanish, Moorish
Tube: Farringdon, Angel
Map: No. 34

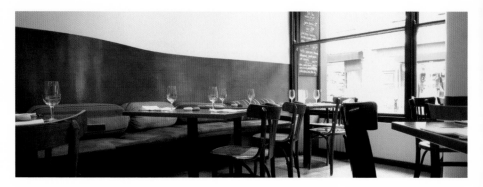

The atmosphere of the Moro is as warm and lively as that of Spain or Portugal. There is an open view of the kitchen at the back of the large room. The predominantly Moorish cuisine by the husband-and-wife chef-owners, who are passionate cooks, has received several awards. More than 100,000 copies of the *Moro Cookbook* have been sold.

L'atmosphère du Moro est aussi chaleureuse et vivante qu'en Espagne ou au Portugal. Au bout de la grande salle, la vue s'ouvre sur la cuisine. La cuisine mauresque du couple de propriétaires, cuisiniers passionnés, a gagné plusieurs prix, et le livre « Moro Cookbook » s'est vendu plus de 100 000 exemplaires.

Una atmósfera cálida y viva como la que se vive en España o Portugal. Desde el fondo de la gran sala se divisa la cocina. Los platos de inspiración árabe, creados con pasión por el matrimonio dueño del restaurante, han sido galardonados en varias ocasiones, y el "Libro de Recetas de Moro" ha vendido ya más de 100 000 ejemplares.

L'atmosfera è calda e vivace, e ci fa sentire aria di Spagna e di Portogallo. In fondo all'ampio salone è possibile osservare la cucina, aperta. I piatti sono ispirati alla cultura moresca e preparati con passione dai titolari. Il ristorante è stato più volte premiato e il "Libro di Ricette del Moro" ha venduto oltre 100 000 copie.

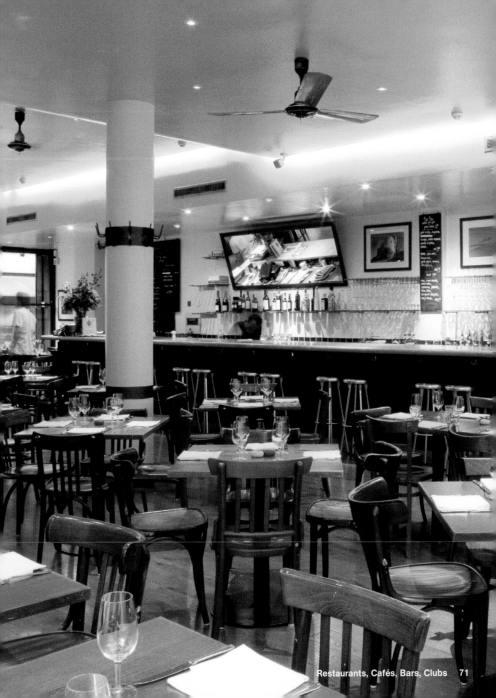

Baltic

74 Blackfriars Road
London
SE1 8HA
Southwark
Phone: +44 / 20 / 79 28 11 11
www.balticrestaurant.co.uk

Opening hours: Mon–Sat noon to 2.30 pm, 6 pm to 11.15 pm,
Sun noon to 2.30 pm, 6 pm to 10.30 pm
Prices: Two course lunch menu from £ 11.50
Cuisine: Easter European
Tube: Southwark
Map: No. 3

The interior of this restaurant in a former coach factory is as elegant as it is simple. Live jazz is free here every Sunday. The Eastern European cuisine with a wide range of fish specialties is actually good value for the money considering its outstanding quality. You can pair it with the many types of vodka.

L'intérieur de ce resto, logé dans une ancienne manufacture de carrosses, est aussi élégant que simple. Chaque dimanche, il y a du jazz live gratuit. La cuisine d'Europe de l'est, d'une qualité exceptionnelle, propose un grand choix de plats de poissons à des prix raisonnables. De plus, il y a de nombreuses sortes de vodka.

El interior de este local, ubicado en un antiguo taller de carrozas, es tan elegante como sencillo. Los domingos se puede escuchar música jazz en vivo gratis. Su cocina de Europa del Este, con una buena variedad de especialidades de pescado, no es cara en absoluto para la excelente calidad que ofrece. A ello se suma la gran selección de Vodkas.

La decorazione di questo locale, antica manifattura di carrozze, è tanto elegante quanto semplice. Tutte le domeniche si può ascoltare gratuitamente musica jazz dal vivo. La cucina est-europea è di eccellente qualità, in particolare per il pesce, e non troppo cara. Assai ricco l'assortimento di vodka.

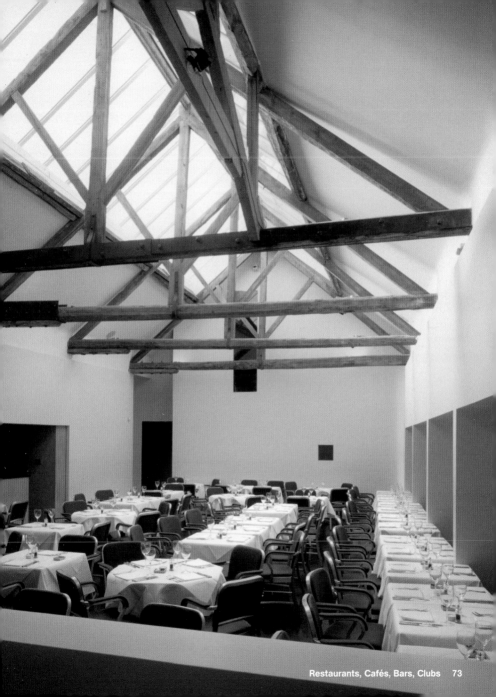

Wagamama

1 Clink Street
London
SE1 9BU
Southwark
Phone: +44 / 20 / 74 03 36 59
www.wagamama.com

Opening hours: Mon–Sat noon to 11 pm, Sun to 10 pm
Prices: Average price entree £ 8
Cuisine: Asian inspired
Tube: London Bridge
Map: No. 56

This light-filled Wagamama location offers creative cuisine that is light and Asian-inspired. Plenty of rice and vegetables are served with chicken or tofu, prepared in a sophisticated way with Far Eastern spices and, of course, large amounts of ginger and chili. There are sometimes lines to the door, but it is worth the wait.

La filiale, baignée de lumière de Wagamama, propose une cuisine créative et légère d'inspiration asiatique. Il y a beaucoup de riz et de légumes avec de la volaille ou du Tofu, préparés avec raffinement avec des épices asiatiques et beaucoup de gingembre et de chili. On fait quelquefois la queue jusque devant la porte, mais cela vaut la peine.

Esta sucursal de Wagamama inundada de luz ofrece cocina creativa y, liger, a de inspiración asiática. En los platos predominan el arroz y las verduras con ave o tofu, refinadamente preparados con especias asiáticas y por supuesto jengibre y pimienta abundante. Aunque de vez en cuando hay que hacer cola para entrar, merece la pena.

Questa illuminatissima succursale Wagamama offre cucina creativa e leggera di ispirazione asiatica. Predominano il riso, le verdure, con pollo o tofu, finemente preparati e speziati all'orientale, e naturalmente ogni tipo di zenzero e chili. A volte c'è da fare un po' di fila, ma ne vale la pena.

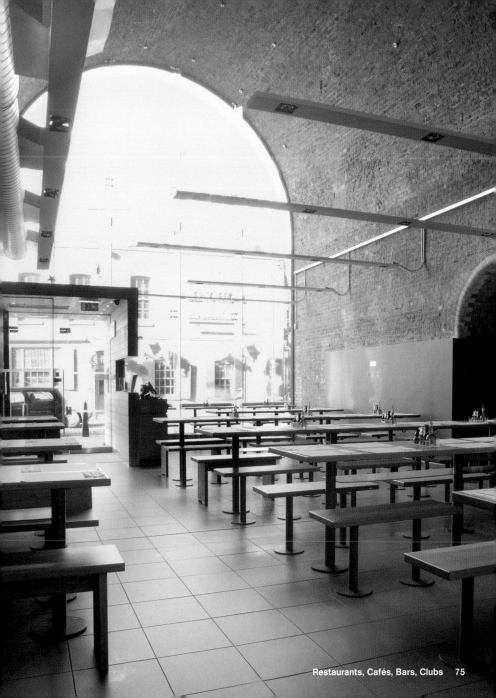

Tom's Delicatessen

226 Westbourne Grove
London
W11 2RH
Notting Hill
Phone: +44 / 20 / 72 21 88 18

Opening hours: Mon–Sat 8 am to 6.30 pm, Sun 9 am to 6.30 pm
Prices: Average price entree £ 9
Cuisine: Modern English, delicatessen
Tube: Notting Hill Gate
Map: No. 52

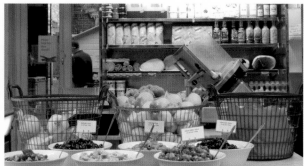

Tom Conran's combination of café and deli offers all kinds of treats like delicious salads, crisp grilled sandwiches, steaming cheesecake, or pancakes. In addition, various freshly squeezed juices are served. The seats in the garden or on the galley are popular—but you can also take the delicacies away with you.

La combinaison de café et déli de Tom Conran offre diverses gourmandises, comme de délicieuses salades, des sandwichs croustillants, des gâteaux au fromage encore chauds ou des crêpes. Avec ceci, on y sert des jus de fruits fraîchement pressés. Les places dans le jardin ou sur la galerie sont très convoitées – mais ces délices sont aussi à emporter.

Esta fusión de café y deli de Tom Conran ofrece todo tipo de deliciosas ensaladas, sándwiches crujientes a la parrilla, esponjosas tartas de queso o crepes, acompañadas por zumos variados recién exprimidos. Las mesas del jardín y de la terraza son las más solicitadas, aunque las exquisiteces también están disponibles para llevar.

La combinazione tra caffè e deli ideata da Tom Conran offre ogni tipo di squisitezze, tra cui deliziose insalate, croccanti sandwich alla griglia, vaporose torte di formaggio e frittelle. Il tutto accompagnato da succhi di frutta appena spremuti. Molto ambiti i posti in giardino e nel portico. Questi squisiti piatti si possono anche portare via.

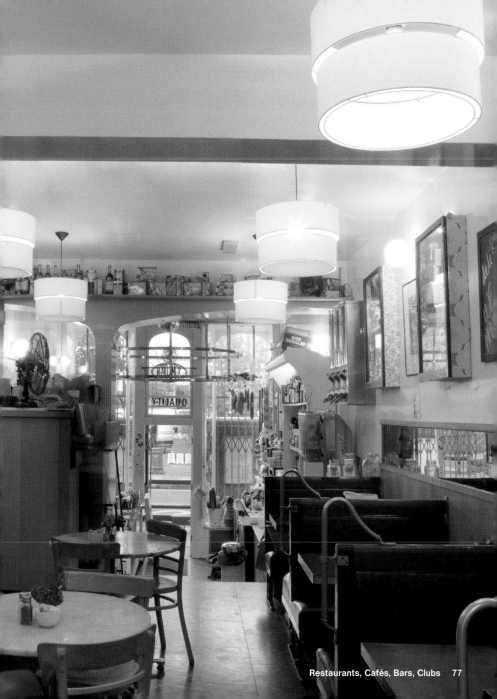

The River Café

Thames Wharf
Rainville Road
London
W6 9HA
Hammersmith
Phone: +44 / 20 / 73 86 42 00
www.rivercafe.co.uk

Opening hours: Mon–Sat 12.30 pm to 5 pm, Sun noon to 5 pm,
Mon–Thu 7 pm to 11 pm, Fri+Sat 7 pm to 11.15 pm
Prices: Average price entree £ 28
Cuisine: Italian
Tube: Hammersmith
Map: No. 40

Even the television chef Jamie Oliver trained with the women owner-chefs of the famous River Café. Both the modern-Mediterranean cuisine and Sir Richard Rogers' simple but elegant architecture for the complex of buildings are a sensation. When the sun shines, you can dine at the center of the herb garden.

Même le cuisinier de la télévision Jamie Oliver s'est formé chez les femmes qui sont les propriétaires et les cuisinières du fameux River Café. La cuisine méditerranéenne moderne ainsi que l'architecture simple mais noble de ce complexe du Sir Richard Rogers font sensation. Quand le soleil brille, on peut dîner au milieu du jardin potager.

El cocinero televisivo Jamie Oliver también ha aprendido de las propietarias y cocineras del famoso River Café. Tanto la moderna cocina mediterránea como la arquitectura noble y sencilla a la vez de Sir Richard Rogers causan sensación. Cuando sale el sol, también se puede comer en medio del su jardín de hierbas frescas.

Il famoso cuoco televisivo Jamie Oliver ha imparato molto dalle proprietarie e cuoche del celebre River Café. Sensazionali sia la cucina moderna-mediterranea sia l'architettura di Sir Richard Rogers, modesta e nobile allo stesso tempo. Nelle belle giornate è possibile pranzare tra le erbe aromatiche del giardino.

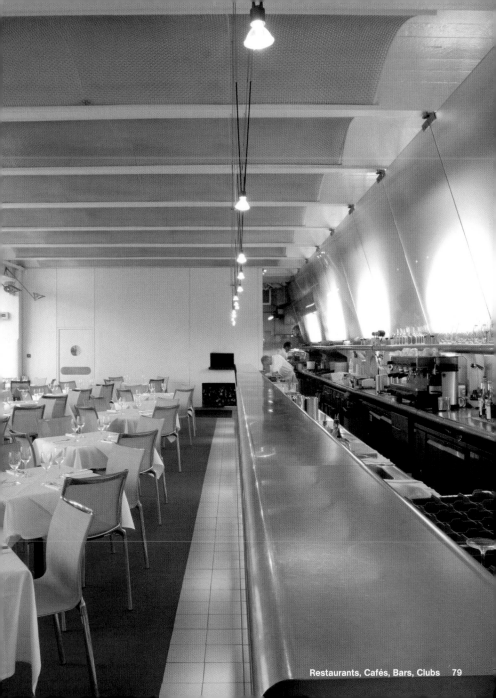

Shopping

You can find everything under one roof at department stores like Selfridges, Debenhams, or Harrods—unfortunately, they are usually much too crowded. If you have more time, be sure to discover the many little stores that are lovingly decorated and run with a passion. They can be found in almost every quarter. Or, of course, go to the flea markets. Pay attention to the quantity discounts (*Buy two, get one free*) and sales.

Dans des grands magasins comme Selfridges, Debenhams ou Harrods, on peut tout trouver sous le même toit – malheureusement, il y souvent la cohue. Quiconque a davantage de temps devrait découvrir toutes ces petites boutiques soigneusement décorées et gérées avec passion, qui existent dans presque chaque quartier. Ou les brocantes. Attention aux rabais quantité (*Buy two, get one free*) et aux soldes (*Sales*).

En grandes almacenes como Selfridges, Debenhams o Harrods se encuentra de todo – ¡Lo malo es que están siempre llenos! Quienes dispongan de más tiempo deberían descubrir los comercios pequeños decorados y regidos con encanto, que hay en casi todos los barrios. Y, por supuesto, los mercadillos. Aquí interesa fijarse en las ofertas (*Buy two, get one free*) y en las rebajas (*Sales*).

In grandi magazzini come Selfridges, Debenhams o Harrods si trova di tutto sotto lo stesso tetto – il guaio è che spesso sono troppo pieni. Chi ha più tempo può scoprire i piccoli shops amorevolmente decorati e gestiti che si trovano in quasi tutti i quartieri. Oppure il mercato delle pulci, naturalmente. Attenzione alle offerte speciali (*Buy two, get one free*) e alle svendite (*Sales*).

Left page: Jigsaw in Notting Hill
Right page: Left Debenhams in Oxford Street, right Escada in Sloane Street in Knightsbridge

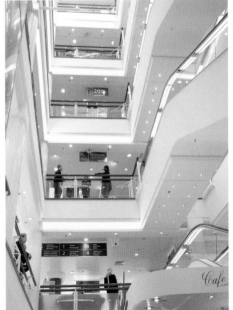

Covent Garden

Covent Garden
London
www.coventgarden.uk.com

Opening hours: Daily 10 am to 8 pm
Products: Fashion, womenswear and menswear, shoes, gifts, jewelry, arts and craft and lots more
Tube: Covent Garden, Leicester Square, Charing Cross
Map: No. 16

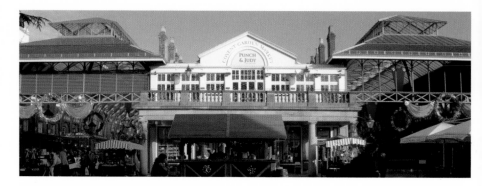

The former market for fruit, vegetables, and flowers is now a district offering endless variety: More than 1,000 restaurants, cafés, bars, and clubs are here. You will also find stores, theaters, ballet schools, cinemas, the Royal Opera House, the National Gallery—and much more. Street performers provide entertainment.

L'ancien marché de fruits, légumes et fleurs est aujourd'hui un district avec une offre infinie : ici, on trouve plus de 1 000 restaurants, cafés, bars et clubs, ainsi que des magasins, théâtres, écoles de danse, cinémas, le Royal Opera House et la Galerie Nationale – et plus encore. Des artistes de rue apportent du divertissement.

El antiguo mercado de frutas, verduras y flores es hoy un distrito con una propuesta infinita más de 1 000 restaurantes, cafés, bares y clubs, además de tiendas, teatros, escuelas de ballet, cines, la Royal Opera House, la Galería Nacional y mucho más. Del espectáculo se encargan los artistas callejeros.

La zona dell'ex mercato della frutta, della verdura e dei fiori offre oggi un'offerta sconfinata: vi si trovano oltre 1 000 ristoranti, caffè, bar e club, oltre a locali, teatri, scuole di balletto, cinema, la Royal Opera House, la National Gallery e molto altro. L'intrattenimento è cura degli artisti di strada.

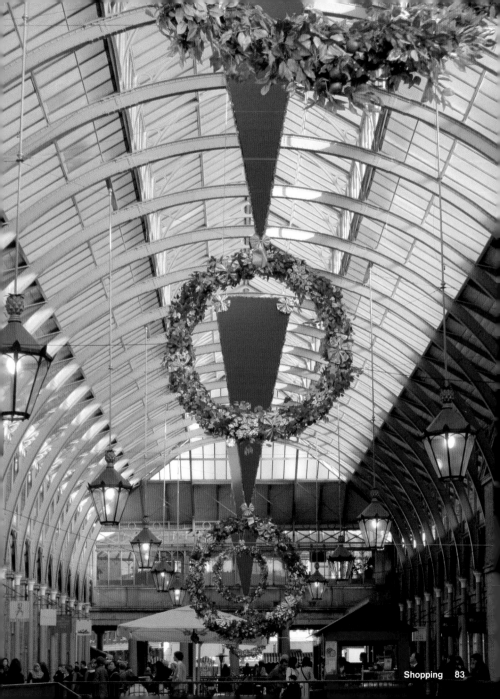

Coco de Mer

23 Monmouth Street
London
WC2H 9DD
Covent Garden
Phone: +44 / 20 / 78 36 88 82
www.coco-de-mer.co.uk

Opening hours: Mon–Sat 11 am to 7 pm, Thu to 8 pm,
Sun noon to 6 pm
Products: Lingerie, erotic literature, tools for bedroom art,
massage oils
Tube: Covent Garden, Leicester Square, Tottenham Court Road
Map: No. 13

Named after a rare and valuable type of coconut, this high-class sex shop with an elegant ambience offers both men and women accessories for sensual experiences. The products range from aphrodisiacs to lingerie to sophisticated stimulating literature. At least the optical pleasure is guaranteed here.

Nommé d'après une sorte précieuse de noix de coco, ce sex-shop haut de gamme offre à tous et à toutes des accessoires pour des aventures sensuelles, des aphrodisiaques et des dessous ainsi que de la littérature érotique exclusive dans une ambiance élégante. Au moins, ici, le plaisir optique est garanti.

El nombre proviene de una rara y apreciada variedad de coco. Este sex shop de alta categoría y ambiente refinado ofrece tanto a hombres como a mujeres accesorios para disfrutar de placeres sensuales, desde afrodisíacos y lencería hasta literatura de alto nivel. Por lo menos dar placer a la vista está garantizado.

Questo raffinato sexy shop, il cui nome deriva da una rara e pregiata varietà di noce di cocco, presenta a un pubblico di alta categoria accessori per esperienze sensuali, dagli afrodisiaci alla lingerie a letteratura stimolante di alto livello. Almeno il piacere della vista è garantito.

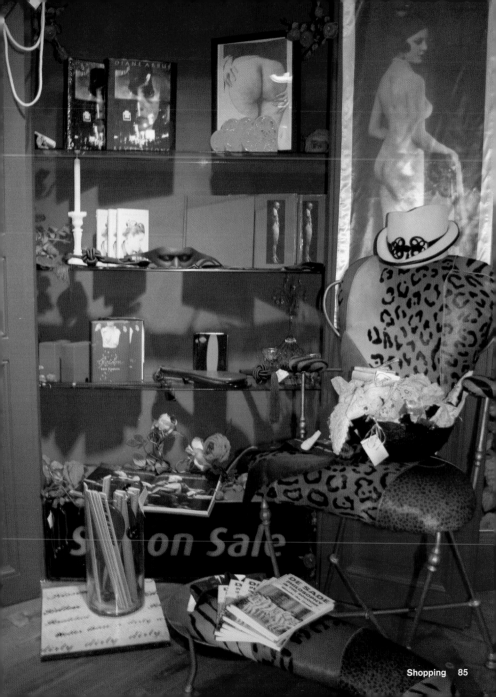

The Tea House

15 Neal Street
London
WC2H 9PU
Covent Garden
Phone: +44 / 20 / 72 40 75 39

Opening hours: Mon–Sat 10 am to 7 pm, Sun 11 am to 6 pm
Products: Teas, herbal teas, tea pots
Tube: Covent Garden, Leicester Square, Tottenham Court Road
Map: No. 50

In one of the most-photographed stores in Covent Garden, a beguiling aroma of teas from around the world will waft around your nose. The shop only sells the best quality, including classics like Earl Grey und Darjeeling. Unusual mixtures can also be found here. In addition, it offers simple and beautiful accessories like cups and teapots.

Dans un des magasins les plus photographiés de Covent Garden, on sent les arômes envoûtants des thés du monde entier. Ici, on ne vend que la meilleure qualité, des produits classiques comme Earl Grey et Darjeeling, ainsi que des mélanges inhabituels. De plus, il y a des accessoires simples, mais jolis, comme des tasses et des théières.

En uno de los locales más fotografiados de Covent Garden flotan los aromas cautivadores de tés de todo el mundo. A la venta se pone sólo la mejor calidad, ya sea la de clásicos como Earl Grey o Darjeeling o de mezclas poco habituales. Además vende accesorios de buen gusto como tazas y teteras.

In uno dei locali più fotografati di Covent Garden, ci si trova circondati da accattivanti aromi dai tè di tutto il mondo. In vendita solo le migliori qualità, tra cui classici come Earl Grey e Darjeeling insieme a miscele meno consuete. Vi si possono inoltre trovare accessori di buon gusto come tazzine e teiere.

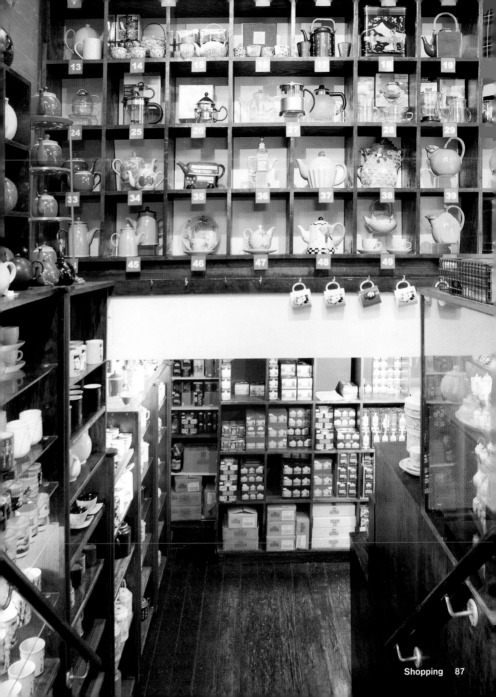

Dunhill

48 Jermyn Street
London
SW1Y 6DL
Mayfair
Phone: +44 / 8454 / 58 07 79
www.dunhill.com

Opening hours: Mon–Sat 9.30 am to 6.30 pm, Sun noon to 5 pm
Products: Leather goods, menswear, timepieces, accessories, writing instruments, luxury gifts
Tube: Piccadilly Circus, Green Park
Map: No. 19

The company founded by Alfred Dunhill in 1893 originally produced leather upholstery for coaches. Products such as driving gloves or the pipe that can be smoked while traveling in a convertible later became fashionable. The exquisite shop offers luxury goods such as select watches, writing implements, leather goods, and the fine Dunhill men's collection.

A l'origine, l'entreprise fondée par Alfred Dunhill en 1893 fabriquait des garnitures en cuir pour des carrosses. Plus tard, des accessoires comme des gants de voiture ou la pipe pour les voitures décapotables étaient à la mode. La boutique exclusive offre des produits de luxe comme des montres précieuses, des ustensiles d'écriture, de la maroquinerie et la noble collection Dunhill pour hommes.

En su origen, la empresa fundada en 1893 por Alfred Dunhill, fabricaba artículos de piel para carrozas. Más tarde se pusieron de moda objetos como guantes y pipas aptas para conducir. El exquisito comercio ofrece artículos de lujo: relojes, material de escritorio, marroquinería y la refinada colección Dunhill para caballero.

L'azienda fondata nel 1893 da Alfred Dunhill produceva originariamente accessori in pelle per carrozze, poi più avanti entrarono in voga altri prodotti, come guanti per l'automobile e la pipa da fumare nel cabriolet. Lo squisito shop offre articoli di lusso come orologi, cancelleria, pelletteria e la raffinata collezione da uomo Dunhill.

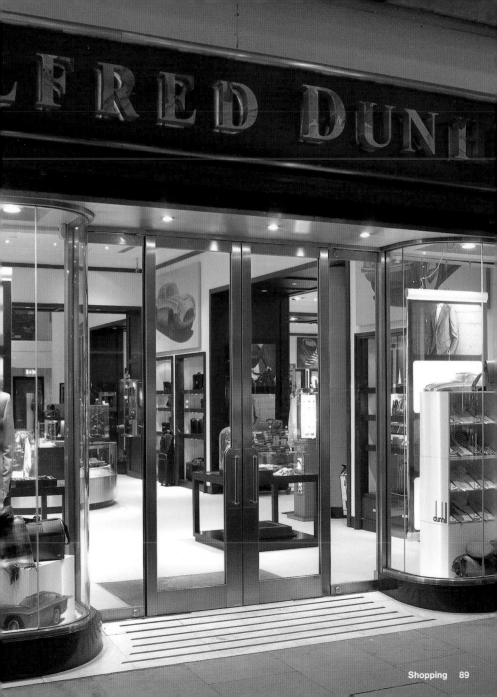

Hamleys

188–196 Regent Street
London
W1B 5BT
Mayfair
Phone: +44 / 870 / 3 33 24 55
www.hamleys.com

Opening hours: Mon–Fri 10 am to 8 pm, Sat 9 am to 8 pm, Sun noon to 6 pm
Products: Toys
Tube: Oxford Circus, Piccadilly Circus
Map: No. 21

The 7-story department store offers many things that children's hearts desire such as life-size stuffed giraffes. Or magic sets, model railroads, cuddly toys, dolls, robot construction kits, games, clothing, and much more. Parents can relax in the café with a cup of tea and still keep an eye on the offspring.

Ce grand magasin de sept étages réalise une grande partie des rêves d'enfants. Tels que, par exemple, girafes en peluche grandeur nature. Ou boîtes magiques, chemins de fer miniatures, peluches, poupées, kits de robot, jeux, vêtements et beaucoup plus. Dans le café, les parents peuvent se détendre avec une tasse de thé tout en veillant sur leurs enfants.

Este almacén de siete plantas tiene mucho que ofrecer a quienes tienen espíritu infantil: jirafas de tamaño natural, cajas de magia, miniaturas de trenes, peluches, muñecas, robots, juguetes, ropa y aún más. En la cafetería, los padres pueden relajarse delante de una taza de té sin perder de vista a los críos.

Questo grande magazzino di sette piani offre tutto ciò che un bambino desidera. Giraffe a grandezza naturale, kit di magia, trenini, peluche, bambole, robot, giocattoli, abbigliamento e molto altro. I genitori possono rilassarsi al bar davanti a una tazza di tè tenendo d'occhio i marmocchi.

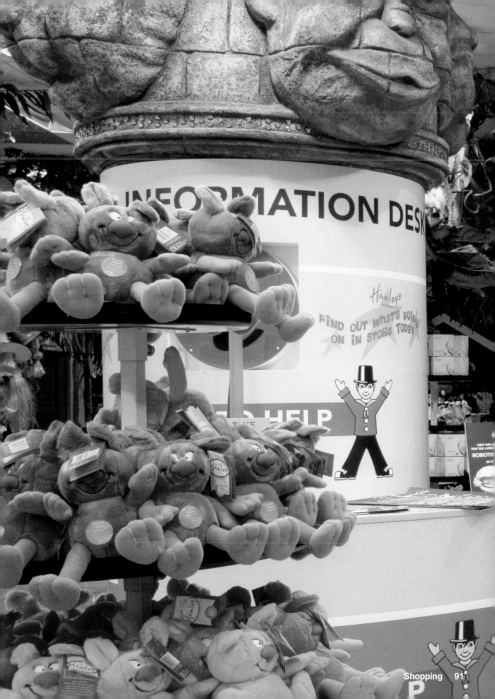

INFORMATION DESK

Hamleys

FIND OUT WHAT'S GOING
ON IN STORE TODAY

HELP

Virgin Megastore

14–16 Oxford Street
London
W1D 1AR
Bloomsbury
Phone: +44 / 20 / 76 31 12 34
www.virginmegastores.co.uk

Opening hours: Mon–Sat 9 am to 10 pm, Sun noon to 6 pm
Products: Everything about music, DVDs, games
Tube: Tottenham Court Road, Oxford Circus
Map: No. 55

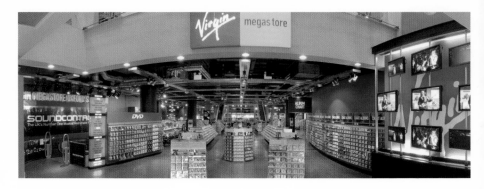

There are hundreds of specialized music stores in the capital city of pop music. But this super department store is the absolute opposite of a cozy record shop. Even unusual sound carriers are in stock and can be listened to before you buy them. In addition to CDs, it carries DVDs, computer games, vinyl, MP3 players, music magazines, and much more.

Dans la capitale de la musique pop, il y a des centaines de magasins de musique spécialisés. Mais ce supergrand magasin est à l'opposé du petit commerce de disques. Même des supports inhabituels du son sont disponibles et peuvent être écoutés pour un test. Outre des CD, on trouve DVD, jeux sur ordinateur, disques vinyle, lecteurs MP-3, journaux de musique et plus encore.

En la capital de la música pop hay centenares de tiendas de discos especializadas, sin embargo, este mega-almacén representa el polo opuesto del comercio tradicional. Aquí es posible encontrar y escuchar todo tipo de excentricidad musical. Además de CDs ofrece DVDs, juegos de ordenador, vinilos, reproductores Mp3 revistas musicales y más.

Nella capitale del pop e del rock troviamo centinaia di negozi specializzati, ma questo supermagazzino si può definire tutto tranne un negozietto! Titoli delle etichette più disparate sono disponibili per l'ascolto e l'acquisto. Oltre a CD presenta DVD, giochi da PC, dischi in vinile, lettori Mp3, riviste musicali e molto altro.

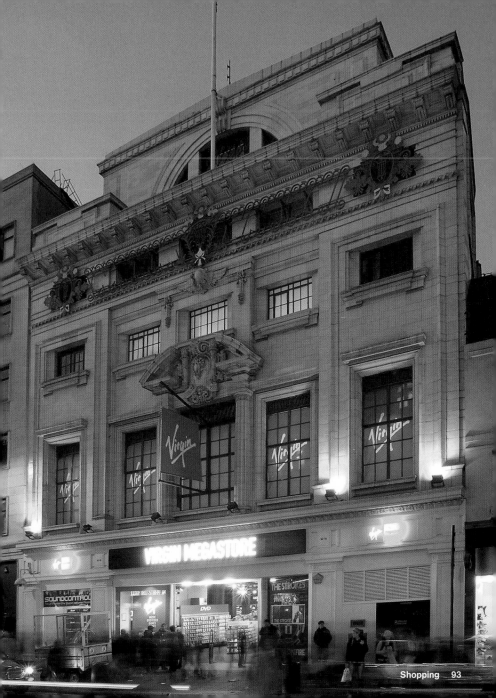

Rococo Chocolates

45 Marylebone High Street
London
W1U 5HG
Marylebone
Phone: +44 / 20 / 79 35 77 80
www.rococochocolates.com

Opening hours: Mon–Sat 10 am to 6.30 pm, Sun 11 am to 4 pm
Products: Chocolate specialities
Tube: Baker Street, Regent's Park
Map: No. 41

Here you will inhale the aroma of dark chocolate while encountering seductively presented bars and boxes decorated with ribbons. For owner Chantal Coady, good chocolate is like a good wine: full of healthy ingredients and by no means comparable to the cheaper mass-produced goods. Rococo only offers top quality.

Ici vous sentez l'arôme du chocolat noir, vous trouvez des tablettes dans une présentation séduisante et des emballages décoratifs. Pour la propriétaire Chantal Coady, un bon chocolat est comme un bon vin: plein de bons ingrédients, absolument pas comparable avec un produit de masse. Rococo n'offre que la meilleure qualité.

Aquí respirará el aroma de chocolate negro presentado en tabletas tentadoras y cajas adornadas con lazos. Para la propietaria Chantal Coady un buen chocolate es como un buen vino: un producto completo y sano, que bajo ningún concepto se puede comparar con los alimentos industriales de bajo precio. Rococo ofrece exclusivamente alta calidad.

Qui si assapora l'aroma del cioccolato nero e ci si lascia tentare da tavolette ben presentate e confezioni con fiocco. Per la proprietaria Chantal Coady, una buona cioccolata è come un buon vino: piena di ingredienti sani e assolutamente da non confondere con prodotti economici di massa. Rococo presenta solo il top.

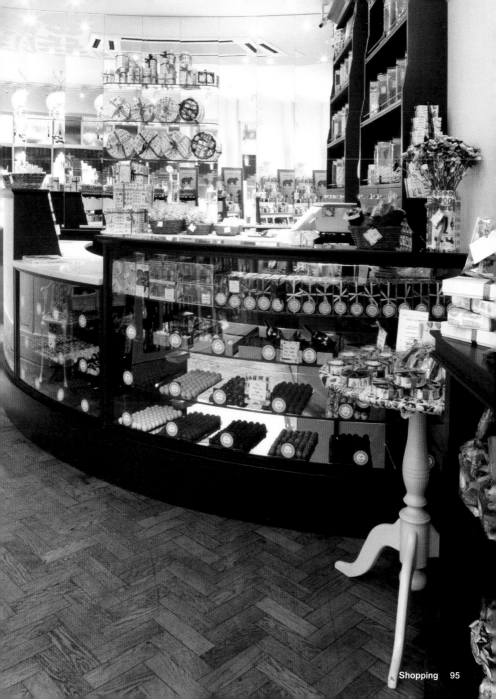

The Conran Shop

55 Marylebone High Street
London
W1U 5HS
Marylebone
Phone: +44 / 20 / 77 23 22 23
www.conranshop.co.uk

Opening hours: Mon–Fri 10 am to 6 pm, Thu to 7 pm, Sat to 6.30 pm, Sun 11 am to 5.30 pm
Products: Everything about interior design on the highest design standard
Tube: Baker Street, Regent's Park
Map: No. 14

Making modern design accessible to more people has always been Sir Terence Conran's aspiration. After the sale of the Habitat chain, he built an international design empire under his own name. From the desk to kitchen lamp, everything is timelessly beautiful, precisely designed, and carefully manufactured.

Cela a toujours été l'ambition de Sir Terence Conran de rendre le design moderne accessible à un public plus large. Après la vente de la chaîne Habitat, il a construit un empire du design mondial sous son propre nom. Du bureau jusqu'à la lampe de cuisine, tout est beau, classique, bien construit et soigneusement fabriqué.

La misión de Sir Terence Conran ha sido siempre conseguir que el diseño moderno sea accesible a un público más amplio. Tras vender la cadena Habitat, construyó el imperio mundial del diseño que lleva su nombre. Desde las mesas a las lámparas de cocina, todo posee una belleza atemporal, estudiada y fabricada muy cuidadosamente.

La missione di Sir Terence Conran è sempre stata: rendere accessibile a un pubblico più vasto il design moderno. Dopo aver venduto la catena Habitat, ha creato un impero mondiale del design che porta il suo nome. Dalle scrivanie alle lampade da cucina tutto ha una bellezza senza tempo, accuratamente studiata e plasmata.

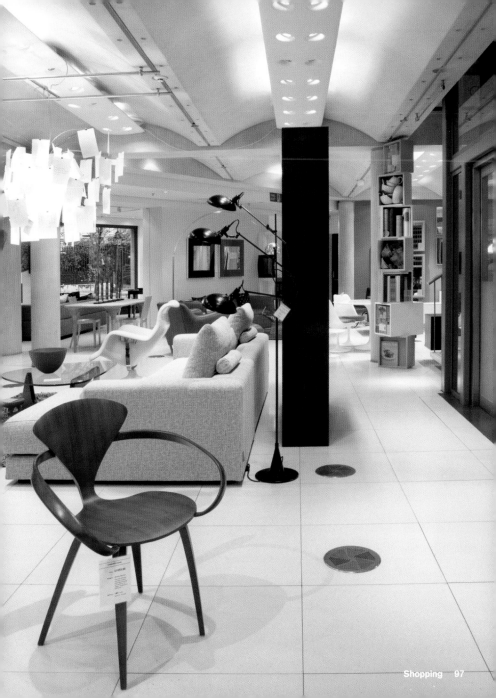

Daunt Books

83 Marylebone High Street
London
W1U 4QW
Marylebone
Phone: +44 / 20 / 72 24 22 95
www.dauntbooks.co.uk

Opening hours: Mon–Sat 9 am to 7.30 pm, Sun 11 am to 6 pm
Products: Travel guides and novels arranged by country, second-hand, travel literature, children's books, books on cookery and interior design
Tube: Baker Street, Regent's Park
Map: No. 17

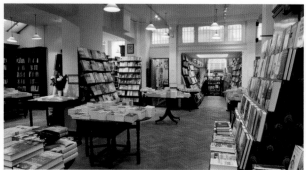

With its polished oak shelves, antique lamps, skylights, and the beautiful gallery, this bookstore evokes another era—but you can also get hardbacks hot off the press here. The books are organized according to countries. All of the titles in the displays have been read by the staff—and given good reviews.

Avec ses étagères briquées en chêne, des lampes antiques, des bandes vitrées et la belle galerie, cette librairie semble sortir d'une autre époque – pourtant, on peut aussi y obtenir les dernières nouveautés. Les livres sont triés par pays. Tous les titres affichés ont été lus – et appréciés – par le personnel.

Con sus pulidas estanterías de roble, lámparas antiguas, claraboyas y su hermosa galería, esta tienda de libros parece pertenecer a otra época; pero a pesar de todo, ofrece también últimas ediciones. Los libros están clasificados por países. Todos los títulos expuestos son leídos y seleccionados por su personal.

Con lucide scaffalature in rovere, lampade antiche, lucernari e la graziosa galleria, questa libreria sembra uscita da un'altra epoca, eppure vi si trovano anche le ultime novità. I libri sono raggruppati per paese. Tutti i titoli segnalati sono stati letti e approvati dal personale.

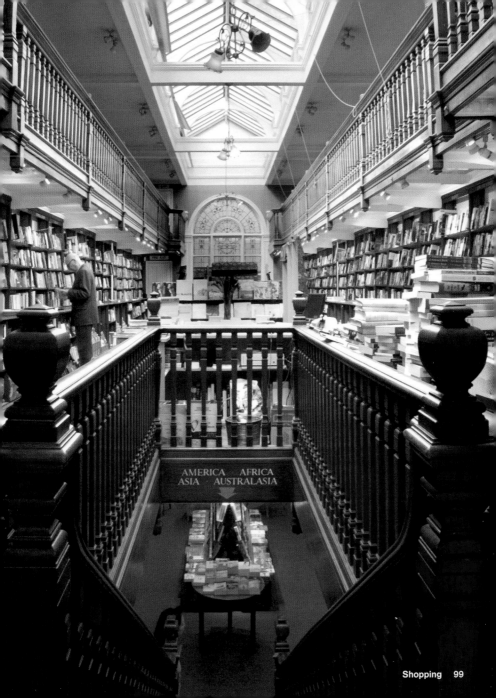

AMERICA AFRICA
ASIA AUSTRALASIA

Harrods

87–135 Brompton Road
London
SW1X 7XL
Knightsbridge
Phone: +44 / 20 / 77 30 12 34
www.harrods.com

Opening hours: Store Mon–Sat 10 am to 8 pm, Sun noon to 6 pm, Food Halls Mon–Sat 9 am to 9 pm, Sun noon to 6 pm
Products: Anything one requires can be purchased by Harrods on one's behalf.
Tube: Knightsbridge
Map: No. 23
Editor's tip: Only well-dressed people are allowed in by the door steward. This means—no shorts or tracksuits.

 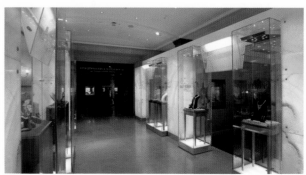

Harrods is one of the oldest, architecturally most impressive, and supremely luxurious department stores in the world. You can buy an individually produced Madame Tussauds wax figure here for £ 250,000 or one of the 300 types of cheese in the delicatessen section. Even if you just want to window-shop: A visit is always worthwhile.

Harrods est un des plus anciens et des plus luxueux grands magasins avec une architectures des plus impressionnantes. Ici, on peut acheter une figure en cire de Madame Tussauds ainsi qu'une des 300 sortes de fromage de l'épicerie fine. Même si l'on ne fait que du lèche-vitrine : une visite vaut toujours le coup.

Es uno de los grandes almacenes más antiguos, lujosos y arquitectónicamente más e impresionantes del mundo, y siempre merece la pena visitarlo, aunque sea sólo sea para mirar. Tan fácil es pedir una figura de cera personalizada de Madame Tussauds por 250 000 £ como una de las 300 variedades de queso de su sección gastronómica.

I grandi magazzini Harrods sono tra i più antichi, lussuosi e architettonicamente impressionanti del mondo. Si può ordinare una statua in cera Madame Tussauds personalizzata per 250 000 sterline come acquistare una delle 300 varietà di formaggio del reparto ricercatezze. Meritano sempre una visita, anche solo per guardare.

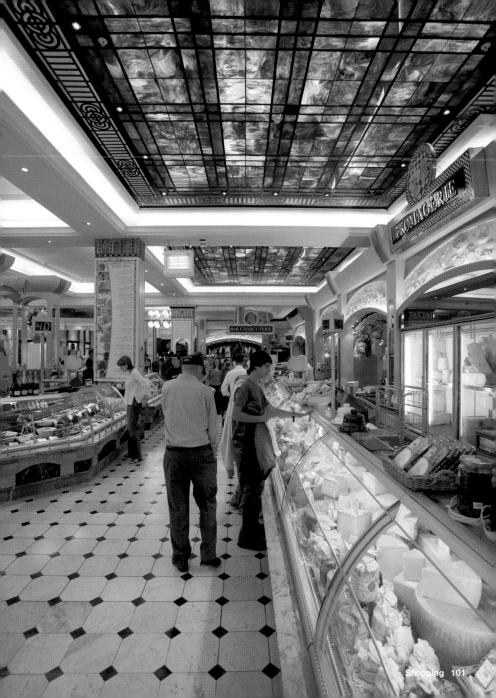

Borough Market

8 Southwark Street
London
SE1 1TL
Southwark
Phone: +44 / 20 / 74 07 10 02
www.boroughmarket.org.uk

Opening hours: Thu 11 am to 5 pm, Fri noon to 6 pm, Sat 9 am to 4 pm
Products: Delicatessen from all around the world, vegetables and fruits
Tube: London Bridge
Map: No. 5
Editor's tip: Try the pies from all the different regions in England with a pint of beer.

 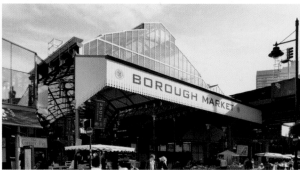

The streets around Borough Market are quite popular—they often appear in feature films. London residents even come from distant parts of the city to buy fruit, vegetables, meat, or bread at this lively market. The Monmouth around the corner is one of London's best coffee specialists.

Les rues autour de Borough Market sont assez populaires – elles apparaissent souvent dans des films au cinéma. Les londoniens viennent même des banlieues éloignées sur ce marché animé pour acheter des fruits, des légumes, de la viande ou du pain. Le « Monmouth » au coin est un des meilleures spécialistes du café de Londres.

Las calles que rodean el Borough Market son muy populares, y con razón, ya que a menudo salen en las películas. Al mercado se le aprecia por sus frutas, verduras, carnes y panes, y atrae a londinenses de todas las zonas. El "Monmouth" en la esquina es uno de los mejores especialistas de café de Londres.

Le vie attorno al Borough Market sono assai famose, visto che compaiono spesso nei film. Il mercato è molto animato, e i londinesi accorrono anche da quartieri remoti per trovare frutta, verdura, carne e pane. Il "Monmouth" all'angolo è tra i migliori specialisti di Londra per i caffè.

Camden Market

Camden High Street and side streets
London
Camden Town
www.camdenlock.net

Opening hours: Daily
Products: Clothing, shoes, jewelry, arts and craft, gifts
Tube: Camden Town, Chalk Farm
Map: No. 10
Editor's tip: The market is also be reached by a romantic boat trip on Regent's Canal. Landing: Little Venice to Camden Lock, www.londonwaterbus.com, Tube: Warwick Avenue.

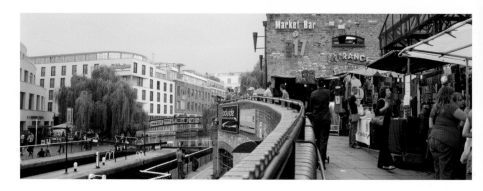

The heart of Camden Market is Camden Lock Market, which opened in the mid-1970s. Most of the stalls with merchandise like jewelry, vintage fashion, furniture, and all kinds of odds and ends are in one hall. More markets have been added since then. The area is considered a great place for musicians to play.

Le cœur de Camden Market est le « Camden Lock Market », ouvert au milieu des années 70. La plupart des stands avec de la bijouterie, de la mode Vintage, des meubles et des objets divers se trouvent dans une salle. Depuis cette époque, plusieurs marchés s'y sont ajoutés. Le quartier est connu comme un lieu de rencontre des musiciens.

El corazón del mercado es el Camden Lock Market, inaugurado a mediados de los años 70. La mayoría de los puestos que venden joyas, moda vintage, muebles y toda clase de trastos se encuentran en un mismo pabellón. Desde sus comienzos se han ido uniendo otros mercadillos a esta zona, frecuentada también por músicos callejeros.

Il cuore della zona è il Camden Lock Market, aperto alla metà degli anni '70. Le bancarelle sono riunite in un padiglione e vendono gioielli, moda vintage, mobili e ogni tipo di cianfrusaglie. Negli anni successivi molti altri mercatini si sono aggiunti, e l'area è frequentata anche da molti musicisti di strada.

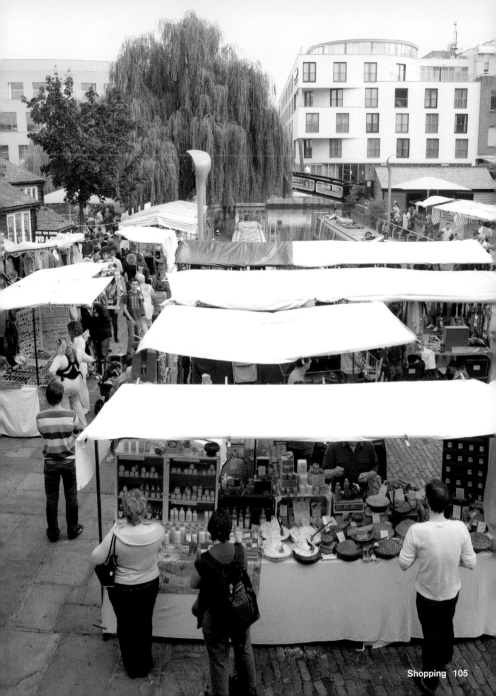

You can lay your weary head on all types of pillows in London: starting with rooms at the time-honored luxury hotels to privately run city lodgings to bed & breakfasts or the big hotel chains that are everywhere in the world. Many of the large establishments also house excellent restaurants and bars. But even the less expensive accommodations are not cheap—be sure to pay attention to special weekend rates.

A Londres, vous pouvez reposer vos jambes fatiguées dans toutes sortes de lits : ceux des hôtels de luxe élégants, ceux des hébergements privés en ville, ceux des « Bed & Breakfast » ou ceux des grandes chaînes d'hôtels internationales. Beaucoup de grands établissements hébergent en outre d'excellents restaurants et bars. Toutefois, même les logements modérés ne sont pas donnés – attention aux tarifs spéciaux pour le week-end.

En Londres hay todo tipo de formas para descansar los huesos: desde renombrados hoteles de lujo hasta pensiones particulares, desde los bed & breakfast hasta las cadenas internacionales. Muchos de ellos cuentan además con excelentes restaurantes y bares. Pero los alojamientos buenos no son baratos; lo ideal, es aprovechar las tarifas especiales de fin de semana.

A Londra esistono vari modi per riposare le stanche ossa, iniziando dagli storici hotel di lusso, proseguendo con pensioni gestite da privati, fino ai bed & breakfast e alle grosse catene internazionali. Molti dei maggiori alberghi comprendono ristoranti e bar eccellenti. Ma nemmeno le pensioni sono poi così economiche, la cosa migliore è approfittare di tariffe speciali per il weekend.

Left page: Blakes
Right page: Left Threadneedles, right Knightsbridge Hotel

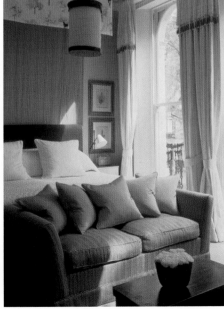

Courthouse Hotel Kempinski

19–21 Great Marlborough Street
London
W1F 7HL
Soho
Phone: +44 / 20 / 72 97 55 55
Fax: +44 / 20 / 72 97 55 66
www.courthouse-hotel.com

Prices: Single room £ 315, double room £ 315, suite £ 645
Services: Full pre-natal massage and beauty therapy for the expectant Mother, private cinema
Tube: Oxford Circus
Map: No. 15

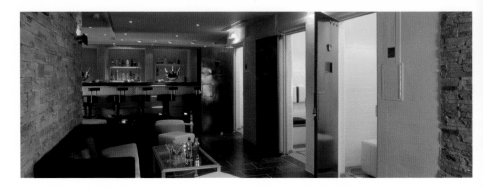

Even the smallest of the 116 rooms in this luxury hotel are larger than some living rooms. They are furnished with every possible amenity such as marble bathrooms, king-size beds, and a wireless Internet connection. You can dine in the "Carnaby Brasserie" or the excellent "Silk Restaurant". The "Sannok Spa" is also open to people who are not guests.

Dans cet hôtel de luxe, même les plus petites des 116 chambres sont plus grandes que certaines salles de séjour et équipées de tout le confort possible comme la salle de bain en marbre, des lits « surdimensionnés » et des connections internet WLAN. On mange dans la « Carnaby Brasserie » ou le noble « Silk Restaurant ». La section des bains « Sannok » est ouverte au public.

En este hotel del lujo hasta las más pequeñas de sus 116 habitaciones son más amplias que muchas salas de estar y están equipadas con todas las comodidades posibles, como baños en mármol, camas gigantes y conexión WIFI a Internet. De la cocina se encargan la "Carnaby Brasserie" y el refinado restaurante "Silk". El centro spa "Sannok" está abierto a huéspedes y a visitantes.

In questo hotel di lusso anche le più piccole delle 116 camere sono ampie come salotti, e attrezzate con tutte le comodità possibili come bagni in marmo, letti enormi e connessione Internet wireless. Per rifocillarsi ci sono la "Carnaby Brasserie" e il raffinato "Silk Restaurant". Il centro termale "Sannok" è aperto a chi non alloggia nell'hotel.

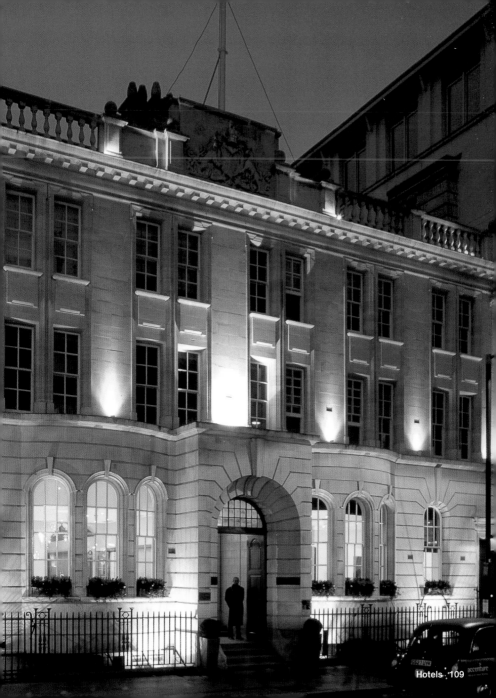

Brown's Hotel

Albemarle Street
London
W1S 4BP
Mayfair
Phone: +44 / 20 / 74 93 60 20
Fax: +44 / 20 / 74 93 93 81
www.roccofortehotels.com

Prices: Single room £ 345, double room £ 410, junior suite £ 900
Services: Concierge, five star kid's programme
Tube: Green Park, Piccadilly Circus
Map: No. 8

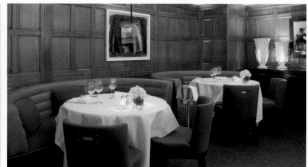

This hotel has stood for top service, discretion, and comfort—and all of this for the past 150 years. Recently given a complete renovation, the 117 rooms, including 19 suites, offer everything for the discerning guest. The "Grill Restaurant" serves English and modern European cuisine. The "Donovan Bar" and "English Tea Room" can also be recommended.

La maison est synonyme de service de première classe, discrétion et confort – et ce depuis 150 ans. Les 117 chambres, dont 19 suites, entièrement rénovées depuis peu, offrent tout pour le visiteur exigeant. Le restaurant « The Grill » sert de la cuisine moderne anglaise et européenne. Le « Donovan Bar » et « The English Tea Room » sont aussi à recommander.

La casa destaca por su servicio de primera calidad, discreción y confort desde hace 150 años. Sus 117 habitaciones recientemente renovadas, entre las cuales se cuentan 19 suites, satisfacen a los huéspedes más exigentes. El restaurante "The Grill" sirve platos ingleses y cocina europea moderna. También valen la pena el "Donovan Bar" y la "English Tea Room".

La casa è sinonimo di servizio di prima categoria, discrezione e comfort, e tutto questo da 150 anni. Le 117 camere recentemente rinnovate, tra cui 19 suite, sono in grado di accontentare l'ospite più esigente. Il ristorante "The Grill" serve cucina inglese ed europea moderna. Raccomandabili anche il "Donovan Bar" e "l'English Tea Room".

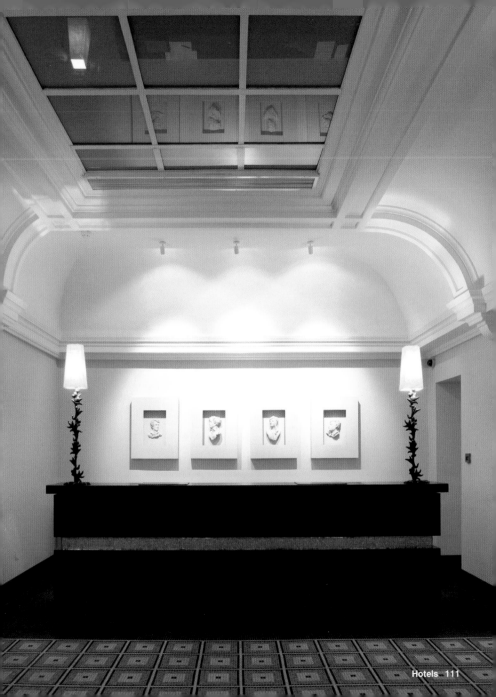

Claridge's

Brook Street
London
W1K 4HR
Mayfair
Phone: +44 / 20 / 76 29 88 60
Fax: +44 / 20 / 74 99 22 10
www.claridges.co.uk

Prices: Single room from £ 500, double room from £ 560, family room from £ 660
Services: Chauffeur, concierge
Tube: Bond Street
Map: No. 12
Editor's tip: If you like bubbly champagne, this is the right spot for you. At "Claridge's Bar", you can expect London's biggest champagne selection–celebrity spotting guaranteed.

 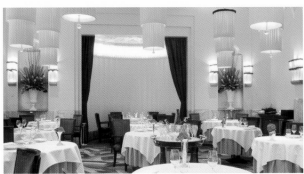

Claridge's is one of the hotels that successfully combines traditional flair with modern comfort. Half of the 203 rooms—including 67 suites—have been designed in art-déco style. The rest are Victorian. Several restaurants and bars, a beauty salon, and a barbershop make it (almost) unnecessary to leave the hotel.

Le Claridge's est un des hôtels qui ont réussi la combinaison d'un flair traditionnel avec un confort moderne. La moitié des 203 chambres – dont 67 suites – est conçue dans le style art-déco, le reste est victorien. Plusieurs restaurants et bars, un salon de beauté et un coiffeur font qu'il est (presque) superflu de quitter l'hôtel.

El Claridge's es uno de esos hoteles que han logrado conciliar un ambiente tradicional con el confort moderno. La mitad de sus 203 habitaciones, incluyendo las 67 suites, están decoradas en estilo Art Deco, y las demás en estilo victoriano. Con los restaurantes, bares, salones de belleza y peluquerías que ofrece casi ni hace falta salir del hotel.

Il Claridge è uno degli hotel che riescono a coniugare atmosfera tradizionale e comfort moderno. La metà delle 203 camere, tra cui 67 suite, sono arredate in stile art-déco, il resto in stile vittoriano. Diversi ristoranti, bar, saloni di bellezza e parrucchieri rendono superfluo uscire dall'hotel ... o quasi.

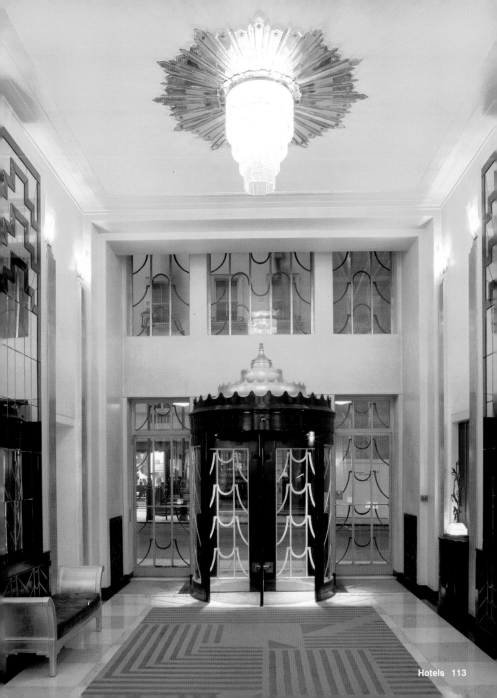

B+B Belgravia

64–66 Ebury Street
London
SW1W 9QD
Belgravia
Phone: +44 / 20 / 72 59 85 70
Fax: +44 / 20 / 72 59 85 91
www.bb-belgravia.com

Prices: Double room £ 99, family room from £ 125 inclusive breakfast
Services: Free internet access, tea and coffees 24 hours daily
Tube: Victoria
Map: No. 2

This establishment, which was distinguished by the Visit London Awards as the best bed & breakfast in town, offers much comfort for a (relatively) low cost. Free Internet access or the 24-hour beverage service are just a few of the many extras. The stylish furnishings of the 17 rooms appear to be on loan from the Design Museum.

Cette maison qui a gagné le prix du meilleur Bed & Breakfast de la ville lors des « Visit London Awards », offre beaucoup de confort à un prix (relativement) modeste au cœur de Londres. Un accès gratuit à l'internet ou un service de boissons 24 h sur 24 ne sont que quelques-uns des nombreux services supplémentaires. L'aménagement de bon goût des 17 chambres semble inspiré du musée du design.

Galardonada con el "Visit London Awards" como mejor bed & breakfast de la ciudad, la casa ofrece gran confort a un relativo bajo precio en el centro de Londres. Entre los numerosos extras se incluye acceso a Internet gratuito y servicio de bar las 24 horas. La elegante decoración de las 17 habitaciones parece haber sido tomada prestada del Museo de Diseño.

Premiato dai "Visit London Awards" come miglior bed & breakfast della città, il Belgravia offre grande comfort in piena città a un prezzo (relativamente) economico. Accesso gratuito a internet o servizio bar 24-su-24 sono solo un paio dei molti extra, e l'arredamento in stile delle 17 camere sembra preso a prestito dal Museo del Design.

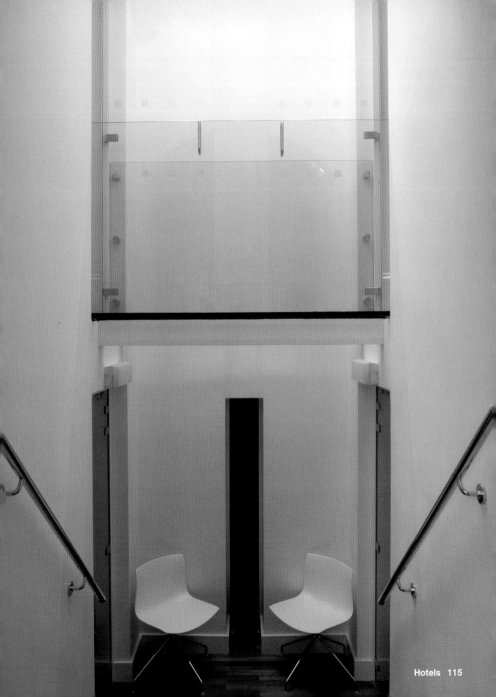

The Rookery

Peter's Lane, Cowcross Street
London
EC1M 6DS
Clerkenwell
Phone: +44 / 20 / 73 36 09 31
Fax: +44 / 20 / 73 36 09 32
www.rookeryhotel.com

Prices: Single room £ 205, double room £ 240
Tube: Farringdon
Map: No. 42
Editor's tip: Perfect for rainy days: the beautiful room with a fireplace.

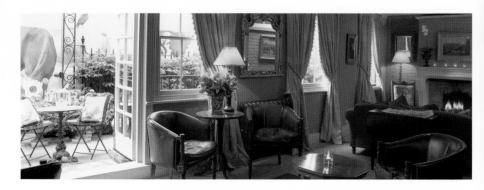

Rookery means a place where birds nest—and this is actually a very English, homey nest at the center of London's financial district. It has a beautiful fireplace parlor and an enchanted inner courtyard. Its 33 luxurious rooms with their different designs are a pleasant contrast to the customary uniform accommodation fortresses.

Rookery signifie nid de corneille – et en effet, ceci est un confortable nid anglais à l'ancienne au milieu du district financier de Londres, avec un beau salon à cheminée et une charmante cour intérieure. Ses 33 chambres luxueuses décorées différemment contrastent agréablement avec l'uniformité des habituelles forteresses hôtelières.

Rookery significa "colonia de grajos", y efectivamente, este hotel es un nido acogedor y británico genuino en el centro del distrito financiero, con su precioso salón con chimenea y un patio encantado. Las 33 habitaciones de lujo, de decoraciones diversas, contrastan agradablemente con los típicos grandes hoteles un tanto monótonos.

Il nome significa "colonia di corvi" e, in effetti, l'hotel è un nido accogliente allo stile "vecchia Inghilterra" in pieno distretto finanziario, con stupendi caminetti e un incantevole cortile interno. Le 33 camere lussuose e variamente decorate offrono un piacevole contrasto con i soliti casermoni tutti uguali.

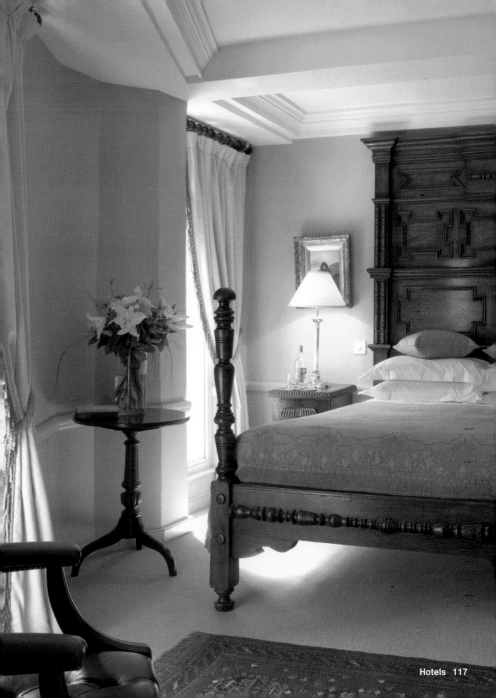

Threadneedles

5 Threadneedle Street
London
EC2R 8AY
City of London
Phone: +44 / 20 / 76 57 80 80
Fax: +44 / 20 / 76 57 81 00
www.theetoncollection.com

Prices: Luxury double from £ 195, studio from £ 265, suite from £ 360
Services: Personalized business cards
Tube: Bank
Map: No. 51

This hotel was selected by "Condé Nast Traveller" as one of the world's Top 50—the "Tatler" even ranked it among the first 20. The building's luxurious interior has been designed down to the last detail. One very impressive feature is the hand-painted glass dome at the center of the hotel, erected as a bank in 1856. The service is exemplary.

Cet hôtel a été sélectionné comme l'un des 50 meilleurs hôtels au monde par « Condé Nast Traveller » – et l'un des 20 meilleurs par « Tatler ». L'intérieur, luxueux, a été pensé jusque dans les moindres détails. Au centre du bâtiment, qui était une banque à sa construction en 1856, la coupole en verre, peinte à la main, est impressionnante. Le service est exemplaire.

Ha sido seleccionado por "Condé Nast Traveller" entre los 50 mejores hoteles del mundo, y por "Tatler" incluso entre los 20 mejores. Su lujosa decoración está cuidada hasta el último detalle. En el centro del edifico, construido en 1856 como banco, destaca su cúpula de cristal pintada a mano. El servicio es ejemplar.

Inserito tra i migliori 50 del mondo da "Condé Nast Traveller", e addirittura tra i primi 20 da "Tatler", l'hotel presenta una decorazione lussuosa e curata nei minimi dettagli. Nel centro dell'edificio, eretto nel 1856 con funzione di banca, colpisce la cupola di vetro dipinta a mano. Il servizio è esemplare.

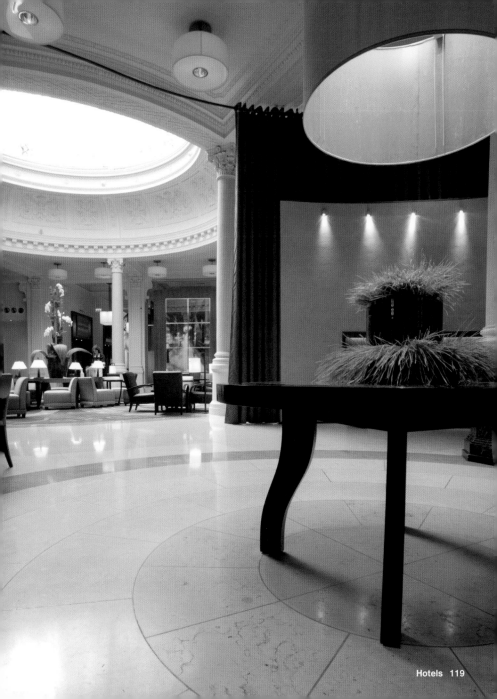

Knightsbridge Hotel

10 Beaufort Gardens
London
SW3 1PT
Knightsbridge
Phone: +44 / 20 / 75 84 63 00
Fax: +44 / 20 / 75 84 63 55
www.firmdale.com

Prices: Single room from £ 175, double room from £ 210, suite from £ 345
Tube: Knightsbridge
Map: No. 28

This small, very special hotel is situated in a quiet but central location. And it is even—relatively—affordable. Each of the 44 rooms has been individually decorated by owner Kit Kemp. There are paintings and sculptures by British artists throughout the building. Attention: Some of the rooms do not have a bathtub.

Ce petit hôtel tout particulier est calme, mais pourtant bien situé au centre. Il est même – relativement – abordable. Chacune des 44 chambres a été individuellement décorée par la propriétaire Kit Kemp. Partout dans la maison, il y a des tableaux et sculptures d'artistes britanniques. Attention : toutes les chambres n'ont pas une baignoire.

Este pequeño y especialísimo hotel, está ubicado en una zona tranquila y a la vez céntrica. Cada una de las 44 habitaciones ha sido decorada individualmente por la propietaria, Kit Kemp. En todos los rincones se encuentran pinturas y esculturas de artistas británicos. Atención: no todas las habitaciones tienen bañera.

Piccolo ma caratteristico, si trova in posizione tranquilla e centrale allo stesso tempo, ed è perciò accessibile (relativamente). Ciascuna delle 44 camere è arredata individualmente dalla proprietaria Kit Kemp, e ovunque si incontrano dipinti e sculture di artisti britannici. Attenzione: non tutte le camere sono dotate di vasca da bagno.

The Lanesborough

Hyde Park Corner
London
SW1X 7TA
Knightsbridge
Phone: +44 / 20 / 72 59 55 99
Fax: +44 / 20 / 72 59 56 06
www.starwoodhotels.com

Prices: Deluxe single from £ 380, deluxe double from £ 525, suite from £ 760
Services: Butler, concierge, complimentary fresh fruit basket replenished daily, complimentary personalized stationary and business cards
Tube: Hyde Park Corner
Map: No. 29

The hotel offers a 24-hour butler service that—so they say—fulfills the guest's every (!) wish. But you can also reside here extremely well even without a butler in one of the 49 luxurious rooms or 46 suites that have been lavishly furnished in the Regency style. The "Conservatory" Restaurant serves exquisite delicacies.

L'hôtel offre un service de groom 24 h sur 24 qui – dit-on – répond à tous (!) les désirs de l'hôte. Mais, même sans groom, on se sent très bien ici, dans l'une des 49 chambres luxueuses ou des 46 suites de style Regency à l'intérieur somptueux. Le restaurant « The Conservatory » sert des mets succulents.

Su servicio de mayordomo las 24 horas hace realidad todo lo deseable y por desear. Y aún sin mayordomo se disfruta de una excelente estancia en cualquiera de sus 49 lujosas habitaciones y 46 suites, ostentosamente decoradas en estilo Regencia. El restaurante "The Conservatory" propone verdaderas exquisiteces.

L'hotel offre servizio di maggiordomo 24 ore su 24, capace di accontentare – così dicono – ogni desiderio del cliente. Anche senza maggiordomo il soggiorno è eccellente nelle 49 camere di lusso o nelle 46 suite arredante in stravagante stile Regency. Il ristorante "The Conservatory" serve squisiti manicaretti.

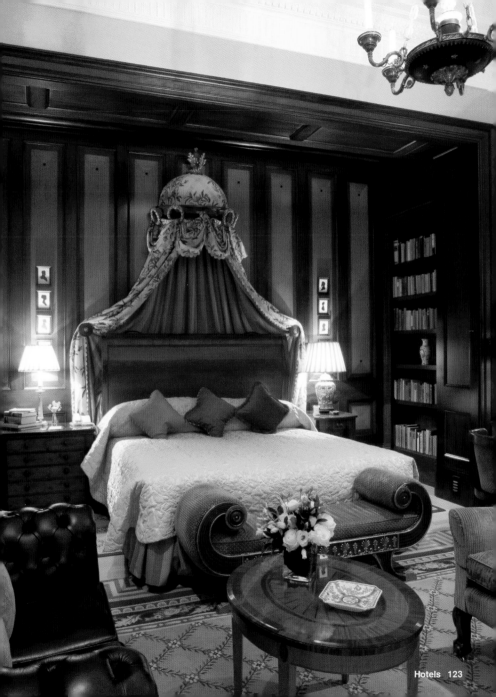

Blakes

33 Roland Gardens
London
SW7 3PF
South Kensington
Phone: +44 / 20 / 73 70 67 01
Fax: +44 / 20 / 73 73 04 42
www.blakeshotels.com

Prices: Single room £ 205, luxury double £ 325, suite £ 665
Services: Wedding service in Suite 007
Tube: Gloucester Road, South Kensington
Map: No. 4

The first hotel decorated by Anouska Hempel is as extravagant and unmistakable as everything else the designer touches. One room has a rather erotic atmosphere, while the next is radiant like a Swedish vacation home. They are all beautiful. The restaurant serves nouvelle cuisine with Middle-Eastern influences.

Le premier hôtel conçu par Anouska Hempel est aussi extravagant et unique que tout ce que touche la créatrice. Si, dans une chambre, l'atmosphère est plutôt érotique, l'autre sera aussi radieuse qu'une maison de vacances suédoise. Elles sont toutes belles. Le restaurant sert de la nouvelle cuisine avec des influences orientales.

El primero de los hoteles decorados por Anouska Hempel es tan extravagante e inconfundible como el resto de las creaciones de esta diseñadora. Mientras en una habitación reina una atmósfera erótica, la de al lado parece una casa de vacaciones sueca. Y sin duda todas son preciosas. El restaurante sirve nuovelle cuisine con influencias orientales.

Il primo tra gli hotel di Anouska Hempel è eccentrico e inconfondibile come gli altri curati dalla designer. Se una camera è dominata da un'atmosfera erotica, quella accanto ricorda una casetta svedese per le vacanze. In ogni caso, tutte sono gradevoli. Il ristorante serve nouvelle cuisine con influssi orientali.

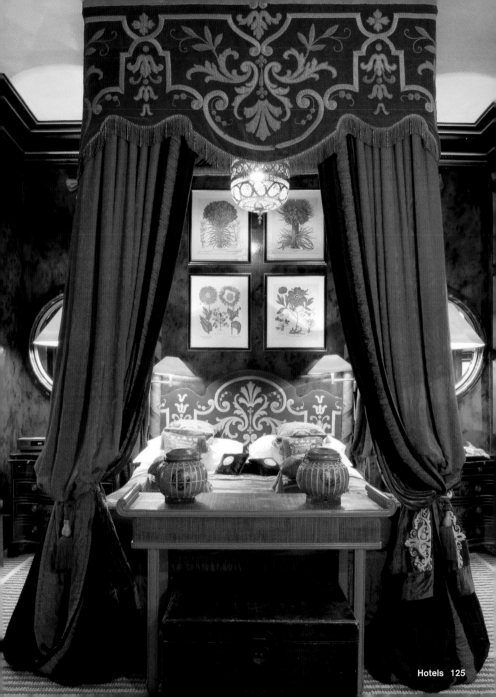

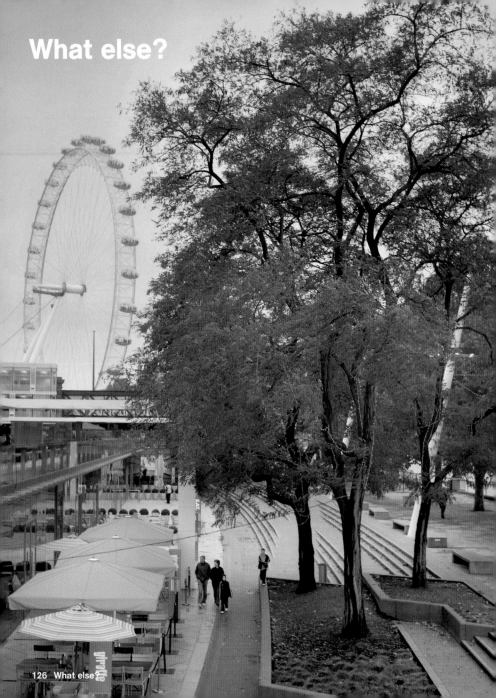

What else?

London offers enjoyable leisure pursuits for the entire family. A visit to Madame Tussauds is just as attractive as a ride on the London Eye ferris wheel or a romantic boat trip. And did you know that London has more green oases than almost any other European metropolis? On top of everything else, many open-air theaters offer stage plays and live music in the summer—and they are almost always free.

Londres offre des loisirs pour toute la famille. Une visite chez Madame Tussaud est aussi intéressante qu'un tour sur la grande roue London Eye ou des sorties romantiques en bateau. Et qui savait que Londres a plus d'oasis vertes que la plupart des autres métropoles européennes? En été, de nombreux théâtres en plein air offrent des pièces de théâtre ou de la musique « live » – presque toujours gratuit.

Londres ofrece diversión para toda la familia. Una visita al Madame Tussauds es tan atractiva como una vuelta en la Noria London Eye o una romántica excursión en barco. ¿Y quién iba a decir que Londres posee tantos oasis verdes, tal vez más que cualquier otra metrópoli europea? Numerosos teatros al aire libre ofrecen a lo largo de todo el verano obras teatrales y música en vivo, casi siempre gratis.

Londra offre opportunità di svago per tutta la famiglia. Una visita da Madame Tussauds può essere interessante quanto un giro sulla ruota panoramica London Eye o una romantica gita in barca. E chi avrebbe mai detto che la città dispone di oasi verdi come forse nessun'altra metropoli europea? Innumerevoli teatri estivi all'aria aperta presentano opere teatrali e musica dal vivo, quasi sempre gratis.

Left page: South Bank with cafés, bars and restaurants and the British Airways London Eye in the background
Right page: Left Richmond Park, right Royal Greenwich Observatory in Greenwich Park

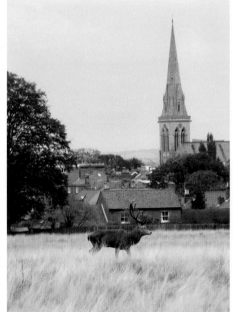

British Airways London Eye

Westminster Bridge Road
London
SE1 7PB
Lambeth
Phone: +44 / 870 / 9 90 88 83
www.londoneye.com

Opening hours: Oct–May daily 10 am to 8 pm, June–Sept 10 am to 9 pm
Admission: £ 14.50, children 5–15 years £ 7.25, children (5 and under) free
Tube: Waterloo, Westminster
Map: No. 6

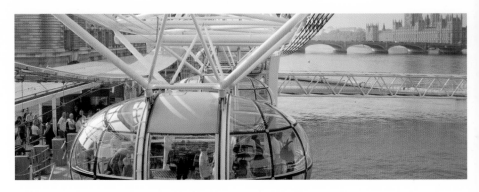

The London Eye—also called the Millennium Wheel—is to London what the Eiffel Tower is for Paris. Since its opening in the year 2000, the technological masterpiece on the banks of the river Thames attracts more than 3.5 million paying visitors per year. For £ 1,700 or more, you can even get married in the 442-foot tall ferris wheel with a spectacular view.

Ce que la Tour Eiffel est à Paris, le London Eye – appelé aussi Millennium Wheel – l'est à Londres. Depuis son ouverture en 2000, ce chef d'œuvre technique sur le bord de la Tamise attire plus de 3,5 millions de visiteurs payants par an. Pour 1 700 £ et plus, on peut même se marier sur cette grande roue panoramique d'une hauteur de 135 m.

Lo que la Torre Eiffel es para París, el London Eye, también llamado Millennium Wheel, lo es para Londres. Desde su apertura en el año 2000 esta maravilla de la técnica a orillas del río Támesis atrae cada año a más de tres millones y medio de visitantes. Por 1 700 £ es posible incluso decir el "sí, quiero" en la noria panorámica a 135 metros de altura.

Chiamato anche Millenium Wheel, il grande London Eye è per Londra ciò che la Torre Eiffel è per Parigi. Dal 2000 questo prodigio della tecnica sulle rive del Tamigi attira oltre tre milioni e mezzo di visitatori all'anno. E per 1 700 sterline si può pronunciare un fatidico "sì"... panoramico da un'altezza di 135 metri.

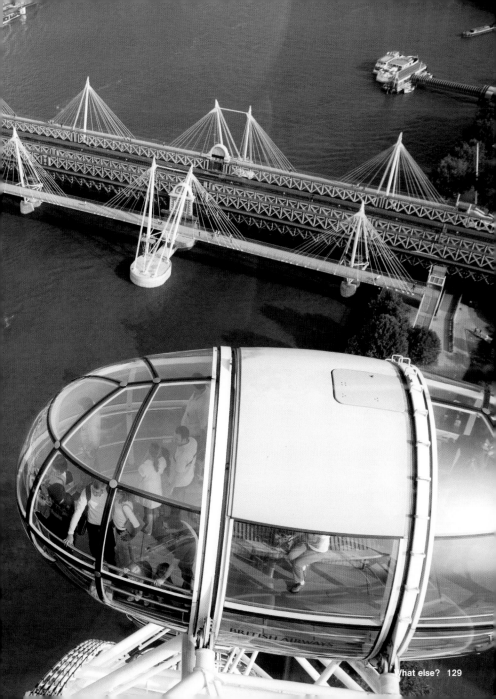

London Aquarium

County Hall
Westminster Bridge Road
London
SE1 7PB
Southwark
Phone: +44 / 20 / 83 32 56 55
www.londonaquarium.co.uk

Opening hours: Daily 10 am to 6 pm, July–Sept to 7 pm
Admission: £ 13.25, children 3–14 years £ 9.75, families
(2 adults + 2 children) £ 44
Tube: Waterloo, Westminster
Map: No. 30

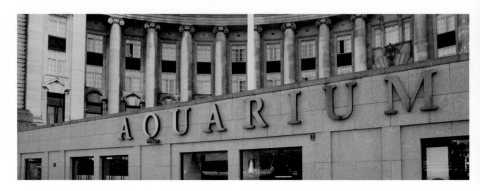

In addition to the sharks, all types of fish are offered for "adoption" here. But the animals stay safe in the care of the aquarium. The money is used for species-preserving breeding programs, for example. The aquarium in County Hall shows 350 species on three levels and is considered to be one of the largest and most attractive in Europe.

Ici, certaines espèces de poissons, dont les requins, sont proposés à l'adoption. Mais les animaux restent en sécurité sous le contrôle de l'aquarium ; l'argent est, par exemple, affecté à des programmes d'élevage pour la préservation des espèces. L'aquarium dans la County Hall montre 350 espèces sur trois niveaux et compte parmi les plus beaux et les plus grands en Europe.

Aquí es posible "adoptar" tiburones y otros tantos tipos de peces. Por supuesto, los animales se quedan bajo la custodia del acuario, mientras que el dinero se emplea por ejemplo en programas de cría. El acuario ubicado en el County Hall expone 350 especies y es uno de los más grandes y bellos de Europa.

Ospitato nella County Hall, l'acquario è tra i più grandi e belli d'Europa e vi si possono ammirare 350 specie diverse. Offre in "adozione" squali e svariati altri tipi di pesci: gli animali rimangono sotto le cure dell'acquario, mentre la donazione viene impiegata per altri scopi, ad esempio per il ripopolamento della specie.

Hyde Park

The Park Office
Rangers Lodge
London
W2 2UH
Phone: +44 / 20 / 72 98 21 00
www.royalparks.gov.uk

Opening hours: Daily 5 am to midnight
Tube: Lancaster Gate, Marble Arch, Hyde Park Corner, Knightsbridge
Map: No. 26
Editor's tip: A very special trip: Hire a horse from the "Hyde Park Stables" (63 Bathurst Mews) and go for a ride in London's biggest park.

The green oasis in the heart of London is also well known for major and small events, with the latter occurring at Speakers' Corner. Since 1872, anyone who feels like it is permitted to hold a speech here on a raised platform. Superstar concerts also take place at this venue. You can have an equally enjoyable time on or around Serpentine Lake.

L'oasis verte au milieu de Londres est aussi connue pour de grands et de petits événements, comme ceux du Speakers Corner, où, depuis 1872, quiconque en a envie peut faire des discours sur une estrade. Il y a également des concerts de superstars. On peut aussi se détendre sur le Serpentine Lake ou autour.

El verde oasis en el centro de Londres es conocido también por las grandes y pequeñas representaciones que tienen lugar; estas últimas en el Speakers Corner, donde desde 1872 quien quiera puede dar discursos sobre un pedestal. En el parque también se dan conciertos de superestrellas. Otra opción es relajarse dando un paseo alrededor o sobre el Serpentine Lake.

Questa oasi verde nel cuore di Londra è conosciuta anche per piccole e grandi manifestazioni; dallo Speakers Corner, dove dal 1872 chiunque ne abbia la voglia può salire su un podio e tenere un discorso, a concerti delle più famose rockstar. Piacevole la passeggiata attorno (e sopra) al Serpentine Lake.

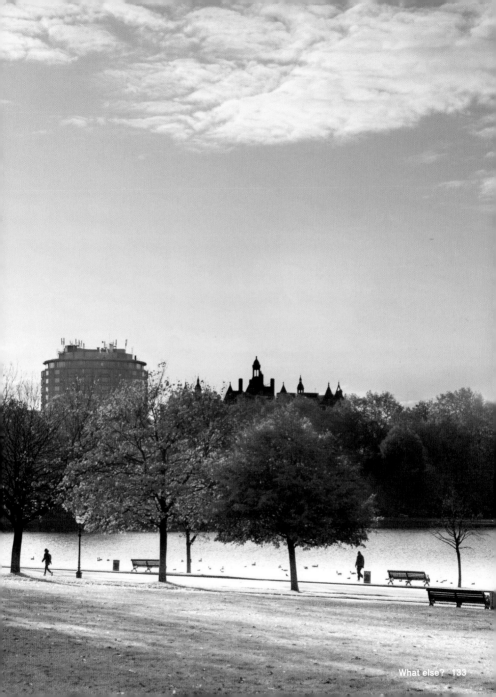

Madame Tussauds London

Marylebone Road
London
NW1 5LR
Marylebone
Phone: +44 / 20 / 74 87 02 00
www.madame-tussauds.co.uk

Opening hours: Daily 9 am to 6 pm
Admission: From £ 19, children (16 and under) from £ 15
Tube: Baker Street
Map: No. 32
Editor's tip: There are two admission points: One where you can buy your ticket and queue for hours and another where you can enter with tickets purchased on the internet—without queue time.

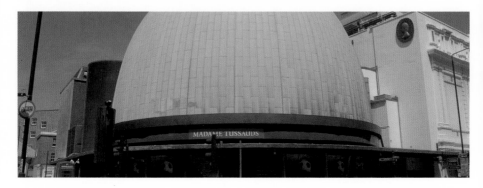

Marie Tussaud learned how to model wax in Paris and began making death masks for victims of the French Revolution. She brought the blade with which Marie Antoinette was guillotined back to England—this is now exhibited in the Chamber of Horrors in the wax-figure museum.

Marie Tussaud a appris le modelage en cire à Paris et a commencé à fabriquer des masques mortuaires des victimes de la Révolution Française. Elle a ramené en Angleterre la lame, avec laquelle Marie Antoinette fut guillotinée – aujourd'hui, celle-ci est exposée dans la « chambre des horreurs » du cabinet de cires.

Marie Tussaud aprendió en París el arte de modelar la cera y empezó preparando máscaras mortuorias de las víctimas de la Revolución Francesa. Se llevó la cuchilla que sirvió para guillotinar a Maria Antonieta hasta Inglaterra, y que ahora está expuesta en la "sala de los horrores" del museo de cera.

Marie Tussaud apprese a Parigi la modellazione della cera e iniziò con le maschere mortuarie delle vittime della Rivoluzione Francese. Portò con sé in Inghilterra la lama che ghigliottinò Maria Antonietta, e che oggi è possibile ammirare (si fa per dire) nella "camera degli orror" del museo.

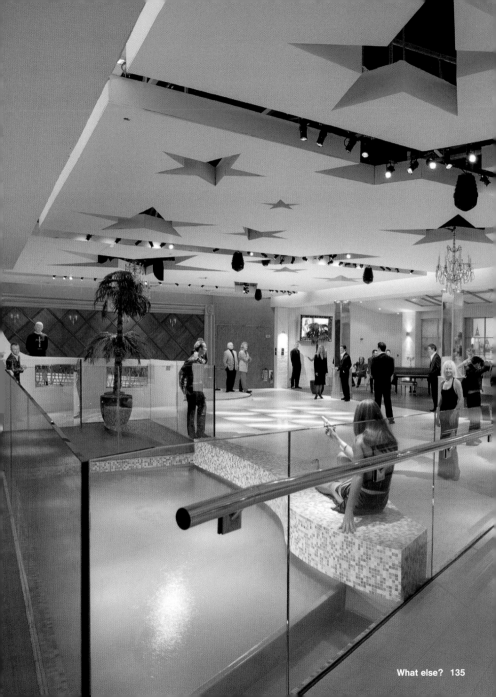

The Regent's Park

The Store Yard
Inner Circle
London
NW1 4NR
Phone: +44 / 20 / 74 86 79 05
www.royalparks.gov.uk

Opening hours: Daily 5 am to sunset
Tube: Regent's Park, Great Portland Street, Baker Street, St John's Wood, Camden Town
Map: No. 38

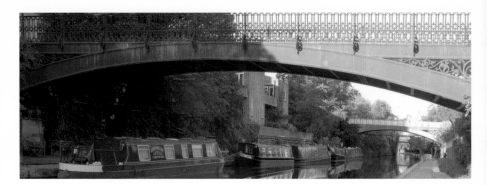

A dream for athletes! It includes training areas for rugby, cricket, soccer, and tennis. Courses in tai chi and yoga are also offered. As much as you may like sports, be sure not to miss out on the rose gardens. They were laid out in 1811 according to the design by architect John Nash.

Un rêve pour les sportifs! Ici, il y a, entre autres, des terrains d'entraînement pour le rugby, le cricket, le football ou le tennis. De plus, des cours de tai chi et de yoga sont proposés. Au-delà du sport, on ne devrait pas oublier de visiter les jardins de roses qui ont été créés d'après un plan de l'architecte John Nash en 1811.

¡Un sueño para los deportistas! Aquí se encuentran, entre otras cosas, áreas de entrenamiento para rugby, críquet, fútbol o tenis, y además se ofrecen cursos de Tai Chi o Yoga. En medio de tanto deporte no hay que olvidar visitar el jardín de rosas, plantado en 1811 según el diseño del arquitecto John Nash.

Un sogno per gli sportivi! Qui troviamo campi di allenamento per rugby, cricket, calcio e tennis, e inoltre possiamo frequentare corsi di Tai Chi e Yoga. Pur presi dalla passione per lo sport, non si dovrebbe dimenticare di visitare i roseti, allestiti nel 1811 su un progetto dell'architetto John Nash.

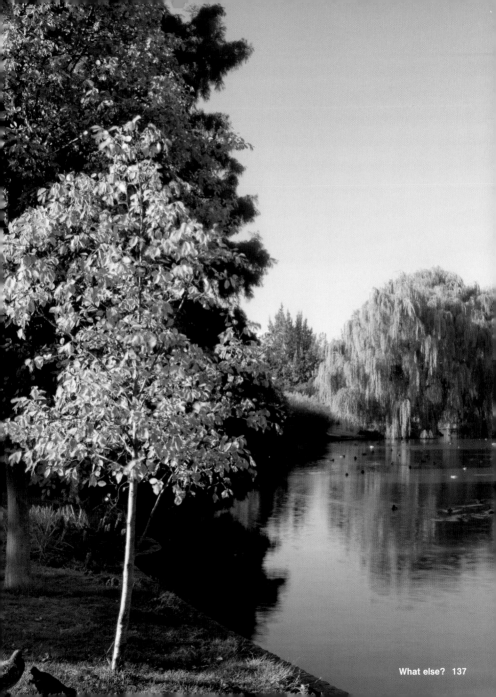

Lord's

St John's Wood Road
London
NW8 8QN
St John's Wood
Phone: +44 / 20 / 76 16 85 95
www.lords.org

Opening hours: Tours operate daily, apart from during major matches and on preparation days; April–Sept daily 10 am, noon and 2 pm, Oct–March daily noon and 2 pm
Admission: Tours £ 10, children £ 6, families £ 27; Match from £ 20
Tube: St John's Wood
Map: No. 31

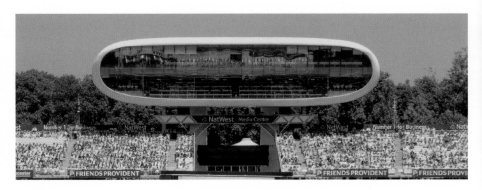

The atmosphere inside Lord's Cricket Ground is even fascinating for people who are not familiar with this sport, especially because of the extraordinary architecture: The "NatWest Media Centre" was voted amongst "The Fifty Best Buildings in Great Britain" in 2001. Matches take place from April to September, but tours are offered throughout the year.

Même pour les profanes, l'atmosphère dans le stade de cricket Lord's est fascinante, particulièrement en raison de son architecture extraordinaire. Le « NatWest Media Centre » a été sélectionné en 2001 parmi « les 50 meilleurs bâtiments en Grande-Bretagne ». Des matchs ont lieu d'avril en septembre, mais les visites sont possibles pendant toute l'année.

La atmósfera en el estadio de críquet Lord's tiene encanto aún para quienes no conozcan este deporte, en parte por su arquitectura atípica: el "NatWest Media Centre" fue seleccionado en 2001 entre las "50 mejores construcciones de Gran Bretaña". Los partidos tienen lugar desde abril hasta septiembre y se ofrecen visitas todo el año.

L'atmosfera in questo stadio per il cricket è affascinante anche per i profani di questo sport, se non altro per la sua architettura poco comune: il "NatWest Media Centre" è stato inserito nel 2001 tra le "cinquanta migliori costruzioni del Regno Unito". Le partite di cricket si svolgono da aprile a settembre, per le visite c'è tempo tutto l'anno.

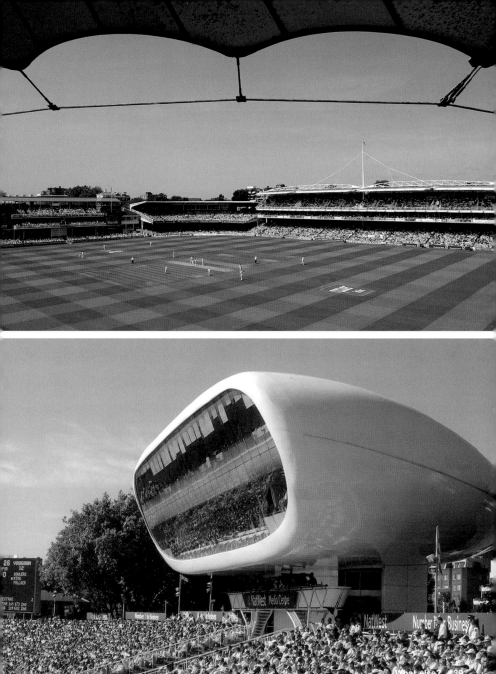

Primrose Hill

North of Regent's Park
Primrose Hill

Tube: Chalk Farm, Camden Town
Map: No. 37

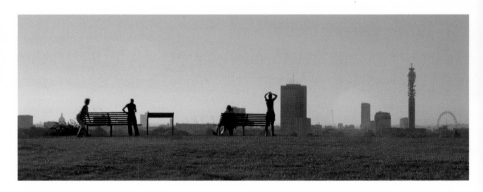

Primrose Hill lies just north of Regent's Park and, like the latter, was previously the hunting grounds of Henry VIII before the land became public property in 1842. The scenery is still refreshingly green despite the central location. The view is wonderful from the top of the hill, which this quarter is named after.

Primrose Hill est situé au nord du Regent's Park, et comme celui-ci, il a jadis été un terrain de chasse d'Henri VIII, avant de devenir une propriété publique en 1842. La verdure est reposante ici, bien que le parc soit très central. Du sommet de la colline qui lui a donné son nom, on a une vue magnifique.

El parque se encuentra al norte del Regent's Park y se conservaba exactamente igual que los antiguos terrenos de caza de Enrique VIII, antes de que se convirtiera en propiedad pública en 1842. Hoy sigue siendo verde, relajante y además bastante céntrico. Desde el punto más alto de la colina que le da nombre se disfruta de una vista maravillosa.

Questa piacevole macchia verde in mezzo alla città si trova a nord di Regent's Park, ed era anch'essa l'antico territorio di caccia di Enrico VIII, prima di divenire proprietà pubblica nel 1842. Il punto più alto della collina da cui l'area prende il nome offre una vista splendida.

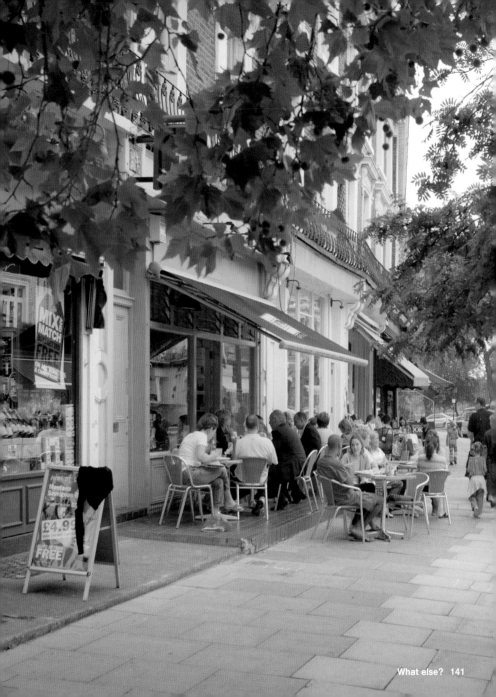

Hampstead Heath

London
Hampstead Heath

Opening hours: Kenwood House daily in winter 11 am to 4 pm, in summer to 5 pm; Park all year round 24 hours daily
Tube: Hampstead and Belsize Park in the west, Golders Green in the north, Highgate and Archway in the east
Map: No. 22

This greenbelt recreation area, which is especially popular in summer, has a horse trail, an adventure playground, tennis and volleyball courts, several swimming ponds, and an outdoor swimming pool. Children are offered magic shows and clown performances. Kenwood House with its small but elegant collection of paintings can also be toured.

Dans ce parc d'attractions à proximité de la ville, particulièrement populaire en été, il y a un sentier de randonnée équestre, un terrain de jeux d'aventures, des terrains de tennis et de volley, plusieurs bassins pour nager et une piscine en plein air. Des spectacles de clowns et de magiciens sont offerts aux enfants. De plus, on peut visiter le Kenwood House avec sa petite, mais jolie collection de peintures.

Esta zona de recreo, popular especialmente en verano, incluye paseos a caballo, parque de aventuras, canchas de tenis y voleibol, y varias piscinas descubiertas. Para los niños tienen lugar espectáculos de magia y de payasos. También se puede visitar la Kenwood House y su colección de pinturas, que es pequeña pero refinada.

Luogo di ricreazione particolarmente amato nei mesi estivi, comprende un sentiero per le passeggiate a cavallo, un parco d'avventure, campi di tennis e pallavolo, diversi laghetti e una piscina all'aperto. Per i bambini ci sono spettacoli di magia e clown. È possibile inoltre visitare Kenwood House con la sua piccola ma raffinata collezione di quadri.

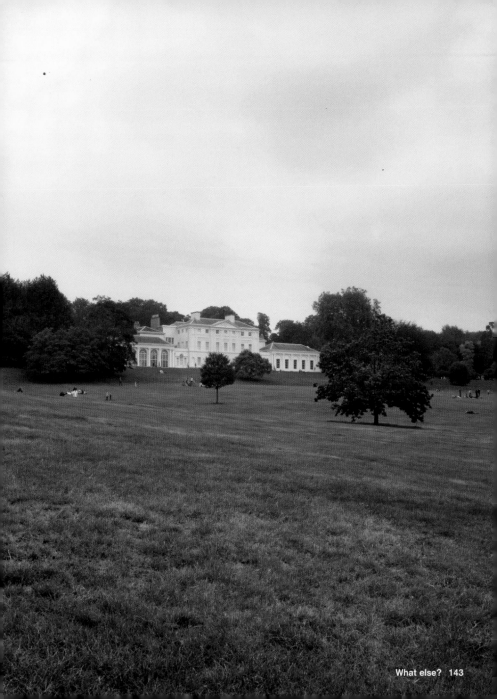

Greenwich Park

Greenwich Park Office
Blackheath Gate, Charlton Way
London
SE10 8QY
Greenwich
Phone: +44 / 20 / 88 58 26 08
www.royalparks.gov.uk

Opening hours: 6 am for pedestrians (and 7 am for traffic) to 6 pm in the winter and 9.30 pm in summer
Tube: North Greenwich—then catch the 188 bus to Greenwich Park gate
Map: No. 20

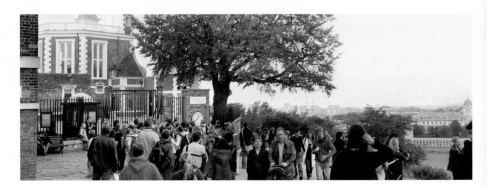

From the elevated park that is a short distance outside London, you have a sweeping view across the Thames. Open-air concerts are presented on Sundays in summer. But a quick trip to the Royal Observatory is worthwhile even if the weather is good because the earth's prime meridian runs through it. Another nearby attraction: the National Maritime Museum.

Du parc situé sur une hauteur, en dehors de Londres, on a une vue panoramique sur la Tamise ; les dimanches d'été, on peut assister à des concerts en plein air. Une visite de l'observatoire Royal Observatory vaut le déplacement, même s'il fait beau, car le méridien zéro de la terre passe par ici. Le National Maritime Museum se trouve également à proximité.

El parque está ubicado hacia las afueras de la ciudad, y desde lo alto se abre una amplia vista a lo largo del Támesis. Los domingos de verano se escuchan conciertos al aire libre. Merece la pena acercarse hasta el Real Observatorio Astronómico, por donde transcurre el meridiano cero, o hasta el adyacente Museo Marítimo Nacional.

Il parco giace su un'altura verso la periferia di Londra, dalla quale lo sguardo si perde lontano lungo il Tamigi. Le domeniche d'estate è possibile assistere a concerti all'aria aperta, e magari fare una deviazione all'Osservatorio Astronomico Reale, origine del meridiano zero della terra. Nelle vicinanze il Museo Marittimo Nazionale.

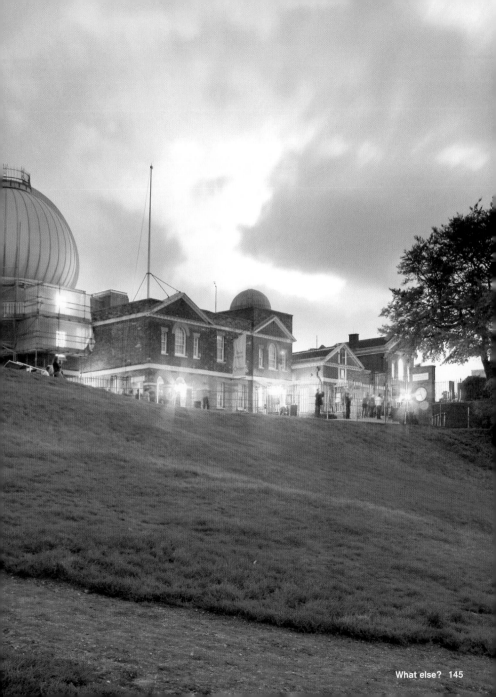

Kew Gardens

Royal Botanic Gardens, Kew
Richmond
TW9 3AB
Surrey
Phone: +44 / 20 / 83 32 56 55
www.rbgkew.org.uk

Opening hours: Daily Nov–Jan 9.30 am to 4.15 pm, Feb+March to 5.30 pm, April–Aug to 6.30 pm, Sept+Oct to 6 pm
Admission: £ 12.25, children (17 and under) free, concessions £ 10.25
Tube: Kew Gardens
Map: No. 27
Editor's tip: Do not miss the small buildings—Queen's Charlotte Cottage and the Chinese Pagoda.

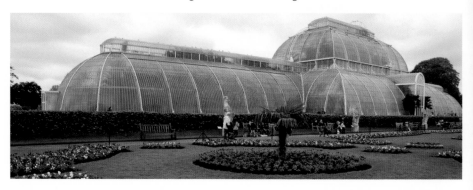

The Palm House in Kew Gardens dating from the Victorian era is considered one of the most beautiful glass-iron constructions in the country. The Chinese-inspired, ten-story pagoda of 1762 is also spectacular. But the actual stars are the plants: giant water-lily leaves or the oldest orchid collection in the world.

La Palm House dans les Kew Gardens, datant de l'époque victorienne, est réputée être la plus belle construction en verre et en fer du pays. La pagode de 10 étages de 1762 d'inspiration chinoise est aussi spectaculaire. Mais les vraies vedettes sont les plantes : d'énormes feuilles de nénuphar ou la plus ancienne collection d'orchidées du monde.

Estos jardines de la época victoriana poseen la más hermosa construcción en vidrio y acero del país, la Casa de las Palmeras. Igualmente espectacular es la pagoda de diez plantas de 1762. Pero las verdaderas estrellas del lugar son las plantas, como los gigantescos lirios acuáticos o la colección de orquídeas más antigua del mundo.

La serra delle palme dei Kew Gardens, risalenti all'era vittoriana, è considerata una delle più belle costruzioni in vetro e ferro della nazione. Altrettanto spettacolare la pagoda cinese a dieci piani, del 1762. Le vere star sono però le piante, come le foglie di loto giganti, o la più antica collezione di orchidee del mondo.

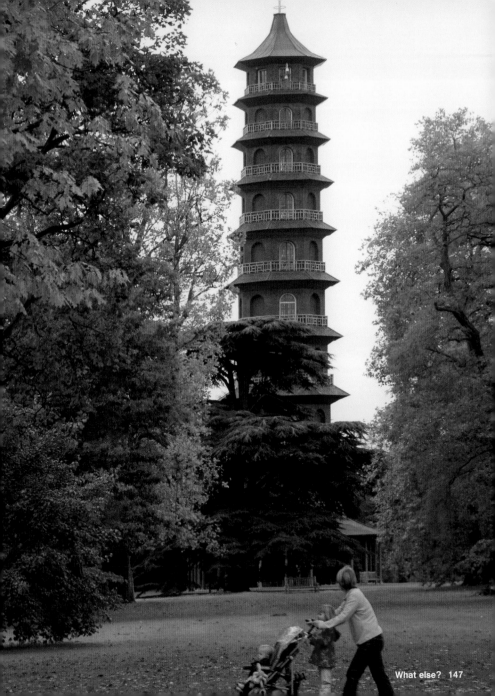

Richmond Park

Richmond Park Office
Holly Lodge
Richmond Park
TW10 5HS
Surrey
Phone: +44 / 20 / 89 48 32 09
www.royalparks.gov.uk

Opening hours: Summer 7 am to sunset, winter 7.30 am to sunset
Tube: Richmond Station
Map: No. 39

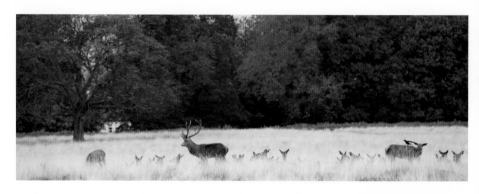

The largest of the royal parks in London and former royal hunting grounds enjoys special protection as a national nature reserve. It has magnificent picnic meadows with a view of the Thames, a public golf course, riding stables, picturesque ponds, a seemingly endless network of bike paths and hiking trails, as well as an old oak forest.

Le plus grand des parcs royaux de Londres et ancien terrain de chasse royal est particulièrement bien protégé du fait que c'est une réserve naturelle nationale. Ici, il y a de magnifiques pelouses pour pique-niquer avec vue sur la Tamise, un terrain de golf public, des centres équestres, des étangs pittoresques, des chemins de randonnée et des pistes cyclables sans fin et une vielle forêt de chênes.

El más extenso de los parques reales de Londres, antiguo terreno de caza de los reyes, goza de protección especial como reserva natural. En él hay áreas para picnic con vistas al Támesis, un campo de golf público, establos, pintorescos estanques, interminables carriles para bicicletas y paseos y un antiguo bosque de robles.

Il più vasto dei parchi reali di Londra, antico territorio di caccia per i sovrani, oggi gode di protezione speciale come riserva naturale. Comprende splendide aree da pic-nic con vista sul Tamigi, un campo da golf pubblico, maneggi, pittoreschi laghetti e interminabili vie pedonali e ciclabili, oltre a un antico boschetto di querce.

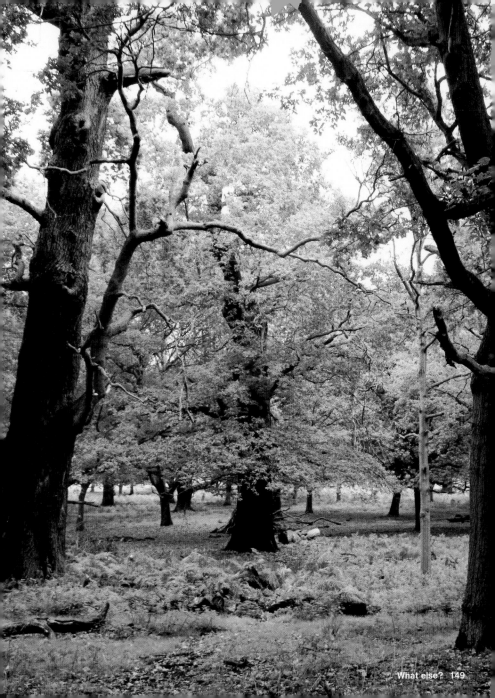

Useful Tips & Addresses

ARRIVAL IN LONDON

By Plane
There are five international airports within a radius of 50 km (31 miles) around London.

City Airport (LCY)
Phone: +44 / 20 / 76 46 00 88
www.londoncityairport.com
Situated in the Docklands about 10 km (6 miles) east of the city. With Docklands Light Railway (DLR) to Bank station, traveling time approx. 22 mins, or in 10 mins to Canning Town station and from there with the Jubilee Line to Westminster station, traveling time approx. 15 mins. With the DLR to Canary Wharf station, traveling time approx. 15 mins, and from there with the Jubilee Line to Westminster station, traveling time approx. 15 mins. A taxi ride to downtown London takes approx. 40 mins and costs approx. £ 20.

Gatwick (LGW)
Phone: +44 / 87 00 00 24 68
www.gatwickairport.com
Situated about 42 km (26 miles) south of London. With Gatwick Express train departing every 15 mins to Victoria station, traveling time approx. 30–35 mins, www.gatwickexpress.com, or with Southern Trains, traveling time 35 mins, www.southernrailway.com. Also every 15 mins with First Capital Connect to London Bridge and King's Cross station, traveling time 30–45 mins, www.firstcapital connect.co.uk. Cheapest option is by coach with National Express Coaches, every 60 mins, traveling time 90 mins, www.nationalexpress. com. A taxi ride to downtown London takes approx. 70 mins and costs approx. £ 80.

Heathrow (LHR)
Phone: +44 / 87 00 00 01 23
www.heathrowairport.com
Heathrow Airport, situated 22 km (14 miles) west of the city center, frequented by scheduled flights. With the Heathrow Express train to Paddington station every 15 mins, traveling time 15 mins, www.heathrowexpress.com. Cheaper option is by tube, every 5 mins, traveling time 50–60 mins, www.thetube.com. A taxi ride to downtown London takes approx. 60 mins and costs approx. £ 40–50.

Luton (LTN)
Phone: +44 / 15 82 / 40 51 00
www.london-luton.co.uk
Situated about 53 km northwest of London. From the airport, free shuttle buses to Luton Airport Parkway train station, from there trains to King's Cross station, traveling time 35–50 mins, www.firstcapitalconnect.co.uk. Every 20 mins buses from easyBus, GreenLine or NationalExpress into London, traveling time 60–80 mins. A taxi ride to downtown London takes approx. 70 mins and costs approx. £ 80.

Stansted (STN)
Phone: +44 / 87 00 00 03 03
www.stanstedairport.com
Stansted airport, situated about 49 km (30 miles) northwest of London, is mainly frequented by low-budget airlines. Every 15 mins with Stansted Express train to London Liverpool Street station, traveling time 45 mins, www.stanstedexpress.com. Several times an hour, with buses from National Express Coaches, Terravision Express Shuttle and Terravision Airport Shuttle to London, traveling time from 55 mins. A taxi ride to downtown London takes approx. 70 mins and costs approx. £ 80.

By Train

There is a direct train connection through the Canal from Paris Gare du Nord, Brussels Midi/Zuid or Lille Europe to London **Waterloo International**. Phone: +44 / 87 05 / 18 61 86, www.eurostar.com or www.raileurope.co.uk. There are eight main **terminal stations** in London: Charing Cross, Euston, King's Cross, Liverpool Street, Paddington, St Pancras, Victoria and Waterloo. All terminal stations have direct access to the tube. Different train operators are in charge.

Further Railway Information

National Rail, Phone: +44 / 84 57 / 48 49 50 and +44 / 20 / 72 78 52 40 (when calling from continental Europe), www.nationalrail.co.uk

Immigration and Customs Regulations

European citizens need a valid identity card for traveling to the UK. For EU citizens there are virtually no custom regulations. Every person at the age of 17 or older is allowed to carry goods for personal needs duty-free, e.g. 3 200 cigarettes, 200 cigars, 3 kg of tobacco, 10 l of liquor, 90 l of wine and 110 l of beer.

INFORMATION

Tourist Information

Visit Britain
Thames Tower
Blacks Road
London W6 9EL
Phone: +44 / 20 88 46 90 00
www.visitbritain.com

Visit London – Britain & London Visitor Centre (BLVC)

1 Lower Regent Street
BLVCEnquiry@visitlondon.com
http://eu.visitlondon.com

Mon–Fri 9 am to 6.30 pm, Sat/Sun 10 am to 4 pm (Sept to 5 pm) The BLVC is run by the official British Tourism Organization Visit Britain. You will receive free information and advice, and also services such as tickets sales, currency exchange and souvenirs. Further Tourist Information Centres (TIC) are located in all airport and at some train stations, such as:

Waterloo International Terminal, Arrival Hall, daily 8.30 am to 10.30 pm
Liverpool Street Station, daily 8 am to 6 pm
Heathrow, Terminals 1 to 3, daily 8 am to 6 pm

City Magazines

Every Tuesday **Time Out** publishes tips on eating out and events for the whole week (available at newsstands). **What's on**, also published on Tuesdays, but less broad. On Thursdays, the **Evening Standard** supplement informs about events such as the supplement of the **Guardian** and other daily newspaper in their Saturday issue. **Time Out Eating & Drinking** is great if you are looking for a restaurant, **Time Out Bars, Pubs & Clubs** informs on the bars' scene, **Time Out Shops & Services** consults where to shop.

Websites

General

www.visitlondon.com – Website of London's tourist information with events calendar and an online ticket shop
www.london.gov.uk – The Mayor's website and information on London
www.bbc.co.uk/london – News from the BBC
www.londontown.com – Tourist information with lots of services such as events calendar, hotel booking

Useful Tips & Addresses

Going out
www.latenightlondon.co.uk – Information on clubs and bars with links
www.squaremeal.co.uk – Restaurant guide
www.thisislondon.co.uk – Leisure guide of the Evening Standard with a great events calendar
www.timeout.com/london – Restaurants, bars and a lot more as well as an extensive culture program

Arts and Culture
www.english-heritage.org.uk – Information on historic buildings, monuments etc. all around Great Britain
www.officiallondontheatre.co.uk – Events calendar, theater plays, tickets
www.royal.gov.uk – Official website of the British Monarchy providing information on Royal residences and art collections

Sports and Leisure
www.citiskate.com – Every Friday inline skating in Hyde Park
www.wsgreyhound.co.uk – Greyhound racing in Walthamstow Stadium
www.ascot.co.uk – Ascot racecourse website

Map
www.london.citysam.de – Interactive city map
www.streetmap.co.uk – Address finder with city map

Accommodation
www.bhrconline.com – Agency for hotel rooms
www.hotels-london.co.uk – London hotels in all price ranges and special offers
www.lhslondon.com – Agency of guests rooms in London
www.londonbb.com – Bed & Breakfast offers in London

www.perfectplaces.co.uk – Apartments, also for long-term assignments
www.visitlondonoffers.com – Reservation service of the London Tourist Information

RECOMMENDED LITERATURE

Peter Ackroyd
London: The Biography. Ackroyd, one of Britain's most eminent novelists, describes in his work London as a living organism, with its own laws of growth and change.

Monica Ali
Brick Lane. Nazneen, 19, from Bangladesh is forced into an arranged marriage and finds herself in Brick Lane, little India of London. This is a novel about the multicultural life in the East End of London.

Joseph Conrad
The Secret Agent: A Simple Tale. Greenwich and Soho are the principal sets of the criminal case that is set at the turn of the 20th century.

Charles Dickens
Oliver Twist. The classic of world literature describes the story of the orphan Oliver Twist and points out the appalling state of affairs in Victorian London.

Samuel Pepys
The Diaries of Samuel Pepys. The collection provides a definitive eyewitness account on the years 1660–1669. It offers detailed insight in intrigues and scandals as well as historical descriptions of the coronation of Charles II, The Plague and the Great Fire of London in 1666.

Oscar Wilde
The Picture of Dorian Gray. Wilde describes a

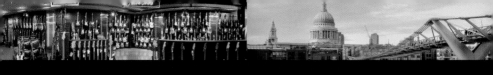

young dandy in search of enjoyment of life without moral taboos set in Victorian London.

Virginia Woolf
Mrs. Dalloway. Clarissa Dalloway prepares for one of her evening parties in June 1923. The reader accompanies her doing her shopping in the mornings in London.

CITY TOURS

Sightseeing Tours

By Bus and Tube
Inner London and a several area in London can be visited to a modest price with public transportation, e.g. with **bus line Riverside 1**, on the south side of the Thames departing from Catherine Street/Aldwych via County Hall and Tate Modern towards Tower Bridge and Tower Hill. Architecture and design fans can head for the tube stations designed by top-architects with the **Jubilee Line**.

Sightseeing Double-Decker Bus
Double-decker buses with an open-air roof circulate every 10 to 30 mins through Inner London, hop on/off is possible at every stop. Daily 8.30 am to 6 pm, 24-hour ticket approx. £18.
Big Bus Company, Phone: +44 / 800 / 169 13 65, +44 / 20 / 72 33 95 33, www.bigbus.co.uk
Original London Sightseeing Tour, Phone: +44 / 20 / 88 77 17 22, www.theoriginaltour.com
Black Taxi Tours
Black taxi tours consider individual desires. Max. 5 pers., 2 hours £ 85, Phone: +44 / 20 / 79 35 93 63, www.blacktaxitours.co.uk
Pedicabs
Bicycle taxis seating from 2–3 pers. wait at several sights for customers to give them a ride through the city.

Boat Tours

Sightseeing
From the Thames you get a remarkable view on the city. The cruises depart all year round from Westminster Pier downstream towards Greenwich and the Thames Flood Barrier, during the season upstream via Kew and Richmond towards Hampton Court. Additional special cruises. Tickets from approx. £10, discount with a valid Travel Card.
Bateaux London, Phone: +44 / 20 / 79 87 11 85, www.catamarancruisers.co.uk
City Cruises, Phone: +44 / 20 / 77 40 04 00, www.citycruises.com
Thames River Boats, Phone: +44 / 20 / 79 30 20 62, www.wpsa.co.uk
London Duck Tours
Yellow amphibious vehicles allow combined sightseeing, both by road and on the Thames, daily departure at the London Eye, duration approx. 75 mins, Phone: +44 / 20 / 79 28 31 42, www.londonducktours.co.uk, £17.50.
Canal tours
Boat trip along the Regent's Canal from Little Venice, London Zoo and Camden Lock.
London Waterbus Company, Phone: +44 / 20 / 74 82 26 60, www.londonwaterbus.com
Jason's Trip, Phone: +44 / 20 / 72 86 34 28, www.jasons.co.uk

Guided City Tours

Private City Guides
Blue Badge Guides
Phone: +44 / 20 / 74 95 55 04
www.tourguides.co.uk
Tailor-made tours and visits.
Theme tours
The 2-hour walks bring you e.g. to the Roman history of the city, through Shakespeare's, Sherlock Holmes's or Jack the Ripper's London,

in different parts of the city or in the evening pubs crawls.

Original London Walks, Phone: +44 / 20 / 76 24 39 78, www.walks.com

Architectural Guided Tours
Architectural Dialogue
Phone: +44 / 20 / 73 80 04 12, www.architec turaldialogue.co.uk Every Sat 10 am approx. 3 hour tour.

Silver Jubilee Walkway
www.jubileewalkway.com
On the occasion of Queen Elizabeth II crown jubilee, a 23 km (14 miles) long walkway on both sides of the Thames between Tower Bridge and Lambeth Bridge was developed. From the starting point at Leicester Square just follow the crown pointing in the direction of travel. A map is available at museums and tourist information centers.

Lookouts
British Airways London Eye
www.ba-londoneye.com
A gradual 30 minute flight in high-tech glass cabin of the world's tallest observation wheel (135 m / 440 ft) Sept daily 10 am to 9 pm, Oct–May to 8 pm, £ 13.50.

Ex-Natwest-Tower/Tower 42
25 Old Broad Street
www.tower42.com
Terrific views are offered to guests at the exclusive Champagne Bar Vertigo 42 on the top floor. Mon–Fri noon to 3 pm, 5 pm to 8 pm.

Tower Bridge
www.towerbridge.org.uk
Breathtaking views from the Walkways over the Thames and the riverbank through special viewing windows. April–Sept daily 10 am to 6.30 pm, Oct–March daily 9.30 am to 6 pm, £ 5.50.

St Paul's Cathedral
www.stpauls.co.uk
The dome galleries offer fascinating views of London. Mon–Sat 8.30 am to 4 pm, £ 9.

TICKETS & DISCOUNTS

Ticket Offices

Ticketmasters
Phone: +44 / 870 / 534 44 44
Phone: +44 / 161 / 385 32 11 (when calling from outside the UK)
www.ticketmaster.co.uk
Ticket Center: Greenwich Tourist Information, 2 Cutty Sark Gardens, Greenwich
Mon–Sat 10 am to 4.30 pm

Stargreen
20/21 A Argyll Street
London W1F 7TT
Phone: +44 / 20 / 77 34 89 32
www.stargreen.co.uk
Mon–Sat 10.15 am to 6 pm

tkts – Half Price Ticket Booth
Leicester Square,
Mon–Sat 10 am to 7 pm, Sun noon to 3 pm
Canary Wharf, DLR station,
Mon–Sat 10 am to 3.30 pm
Last minute sales, discount theater tickets for performances the same day, most tickets are sold at half price.
Info: www.officiallondontheatre.co.uk/tkts

Discounts

London Pass
Free admission without waiting time to more than 50 sights as well as discount on city tours and events, in restaurants and recreational facilities etc. It can be combined with a Travel Card for free bus and train journeys. The pass

can be purchased online at www.londonpass.com or at the Britain & London Visitor Center. One day £ 32 and/or £ 37 incl. Travel Card, two days £ 42 and/or £ 55, three days £ 52 and/or £ 71, six days £ 72 and/or £ 110.

Travel Card
Travel Cards are valid for travel on all public transportation. They are available for one, three or seven days. Peak fares are valid all day, Off Peak fares Mon–Fri from 9.30 am and all day on Sat/Sun and legal holidays. The Visitor Travel Card is valid for zones 1+2 in which most sights are located. The card can be purchased in advance at a travel agency or online at Visit Britain, www.visitbritain.com, basic price € 7.50.

Oyster Card
The new Oyster Card comes with a rechargeable chip. The fare for trains and buses is paid electronically. All tickets are half price. The card can be purchased in advance online at Visit Britain, basic price € 19.50.

GETTING AROUND IN LONDON

Local Public Transport

Transport for London
Phone: +44 / 20 / 72 22 12 34 (24 hour service) www.tfl.gov.uk
Information on the tube, Dockland Light Railway, buses, trams and Thames ferries. Information about the line network can be downloaded from the TfL website. Travel Information Centers are at Heathrow Airport, at tube stations such as Victoria, Liverpool Street and Piccadilly Circus.
The **Tube** is the fastest and most comfortable way of transport in London which connects also Greater London. The core of the network is the 'yellow' Circle Line which connects the main train stations. In previous years, the net has been extended by the Jubilee Line and the Dockland Light Railway. Trains operate Mon–Sat 5.30 am to 12.30 am, Sun 7.30 am to 11.30 pm. Tickets are available from a ticket office or from a ticket machine. Tickets must be kept until the end of the journey to get through the ticket barrier. The tube network uses six zones to calculate fares. Single tickets for zone 1 cost £ 3. The tube network is complemented by a dense **bus network**. Night buses are marked with a blue "N" in front of the line number. There are two different bus stops: one is a white sign on a red circle where buses always stop and the other is a Request bus stop with a red sign on a white circle where buses only stop on request by hand signal. Tickets are available from ticket machines at the bus stops. Single fare £ 1.50. Cheaper are Travel Cards or Oyster Cards (see above) that are valid for one day and more.

Taxis
Phone: +44 / 871 / 871 87 10 and
+44 / 20 / 72 72 02 72,
Phone: +44 / 87 00 70 07 00 (only available when calling from a cell phone)

FESTIVALS & EVENTS

Chinese New Year
End Jan/beginning Feb, parades, dragons' dances, fireworks in China Town.

Oxford and Cambridge Boat Race
Beginning of April, rowing regatta of the two universities between Putney and Chiswick Bridge (www.theboatrace.org).

Easter Sunday Parade
Mar/April, fair and parade at Battersea Park.

London Marathon
Mid/end April, from Greenwich to St James's Park (www.london-marathon.co.uk).

Summer Exhibition
In the beginning of June—mid Aug, exhibition of contemporary British artists at the Royal Academy (www.royalacademy.org.uk).

Trooping the Colours
The second Sat in June usually is the official birthday celebration of the monarch with a parade.

Wimbledon Lawn Tennis Championships
End June/beginning July, on a couple of weeks, international tennis championships (www.wimbledon.org).

City of London Festival
End June—mid July, on several weeks, city festival with music, dance and theater performances (www.colf.org).

Pride Parade
In the beginning of July, gay and lesbian parade from Hyde Park towards Victoria Embankment (www.pridelondon.org).

Greenwich & Docklands International Festival
Every weekend in July, open-air dance, theater and music performances along the Thames (www.festival.org).

BBC Henry Wood Promenade Concerts / The Proms
Mid July—mid Sept, series of concerts in the Royal Albert Hall that rounds off with the patriotic Last Night of the Proms (tickets must be booked in advance, www.bbc.co.uk/proms).

Notting Hill Carnival
Last weekend in Aug, Afro-Caribbean festival, Sun "Children's Day Parade," Mon "Main Parade" (www.nottinghillcarnival.org.uk).

Mayor's Thames Festival
One weekend each year in Sept there is an amusement park and street theater along the Thames as well as a lot of nicely decorated boats (www.thamesfestival.org).

London Open House Weekend
Third weekend of Sept, free access to old and new buildings normally closed to the public (www.londonopenhouse.org).

Great River Race
Beginning of Sept, boats race, with dragon and Viking boats, from Ham House towards Isle of Dogs, entertainment (www.greatriverrace.co.uk).

Trafalgar Day Parade
Sun before and/or after 21st Oct, commemoration in honor of the naval hero Horatio Nelson held at Trafalgar Square with a parade of the Marine and a Horse Guard Parade.

Guy Fawkes Day
5th Nov, in commemoration of the foiled gunpowder plot that should have blown up James I and his parliament in 1605, fireworks in a lot of parks around London and a real festivities atmosphere (www.bonefire.org).

USEFUL NOTES

Electricity
Voltage 240 Volt. British sockets have three pin. For continental Europe's typical two pin sockets you will need an adapter.

Money
National currency: Pound Sterling
1 pound (£) = 100 Pence (p)
Exchange rate (as off spring 2007):
£ 1 = approx. € 1.50
€ 1 = approx. £ 0.70
Euros and Dollars can be exchanged in banks and Bureaux de Change, whereas Bureaux de Change generally have a worse exchange rate. At some places, payment in Euro is accepted, yet you will receive Pounds as a change.
Bank and credit cards: With a Maestro Card or a credit card money can be withdrawn at an automated teller machine (ATM). Most of the hotels, restaurants and shops accept credit cards.

Emergency
Emergency Hotline: Phone: 999 (police, fire department, ambulance)

Opening Hours
Banks: Mon–Fri 9.30 am to 3.30 pm, in shopping malls to 5.30 pm as well as Sat 9.30 am to 1.30 pm. Exchange offices are open daily.
Shops: Mon–Sat 9 am/10 am to 6 pm/7 pm, Thu to 8 pm. Major supermarkets are open to 10 pm, some of them 24 hours daily. Several shops and stores open on Sun noon to 6 pm.
Museums: 10 am to 5/6 pm, closing day varies.
Restaurants: Lunch approx. noon to 2 pm, dinner approx. 7 pm to 10 pm.
Pubs: Since the end of 2006, closing time has been abolished; pubs are allowed to open 24/7.

Costs & Money
London is really expensive. Accommodation rates for a double room inclusive breakfast start at about £ 65 for a B&B and a budget hotel. Online bookings are in general much cheaper. An entree in a bar or café starts at about £ 12, in restaurants at least £ 20; takeaway are a cheaper alternative.

Smoking
Smoking is prohibited in enclosed public places, pubs, bars and restaurants (except pubs not serving food).

When to go
The climate is mild and unsettled. Winters are generally snow-free, with predominantly crisp winds and wet and cold weather conditions.

Telephone
Within London: 020
Calling from abroad: +44 + desired phone number without 0
Calling from London: country code + area code without 0 + desired phone number
Operator national: dial 100, international: dial 155
Directory Assistance: Phone:11 85 00
The 8-digit local numbers start with '7' in Inner London and with '8' in Greater London. If there is a connection error you get help from an operator. Most of the old red phone booths are discarded. The new, mostly glass phone booths work with coins, phone cards or credit cards; phone cards are available from newspaper kiosks.

Tipping
A 10–15 % tipping is normal in restaurants if service charge is not included. In pubs you pay at the bar; tipping is unusual. Tipping is expected from taxi drivers, tourist guides, hairdressers and hotel staff.

Time
Great Britain is Greenwich Mean Time (GMT) which is an hour behind continental Europe. Daylight saving corresponds with the dates of continental Europe.

Page	No.	Object	Page
60	31	Lord's	138
114	32	Madame Tussauds London	134
72	33	mo*vida	66
124	34	Moro	70
102	35	National Gallery	36
128	36	National Theatre	46
42	37	Primrose Hill	140
110	38	The Regent's Park	136
22	39	Richmond Park	148
104	40	The River Café	78
32	41	Rococo Chocolates	94
112	42	The Rookery	116
84	43	Royal Albert Hall	54
96	44	Royal Opera House	40
108	45	Shakespeare's Globe Theatre	48
82	46	Sketch	62
98	47	St Paul's Cathedral	26
56	48	Tate Britain	52
88	49	Tate Modern	50
144	50	The Tea House	86
90	51	Threadneedles	118
142	52	Tom's Delicatessen	76
100	53	Tower Bridge	30
44	54	Tower of London	28
16	55	Virgin Megastore	92
132	56	Wagamama	74
146	57	Westminster Abbey	18
120	58	Westminster Cathedral	24
122	59	Yauatcha	68
130			

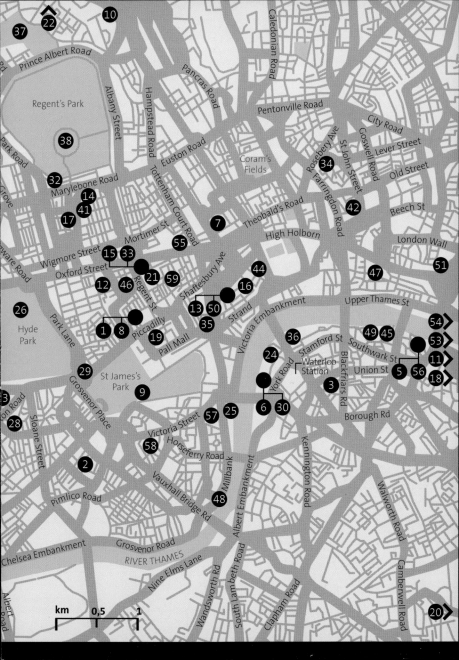

City Highlights INTERNATIONAL EDITION

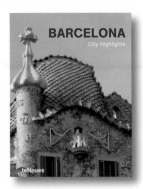

BARCELONA
ISBN 978-3-8327-9192-6

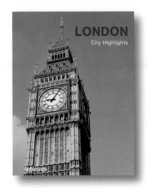

LONDON
ISBN 978-3-8327-9194-0

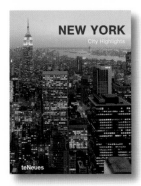

NEW YORK
ISBN 978-3-8327-9193-3

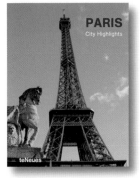

PARIS
ISBN 978-3-8327-9195-7

Size: 15 x 19 cm / 6 x 7 ½ in.
160 pp., Flexicover
c. 300 color photographs
Text in English, French, Spanish and Italian
€ 14.90 $ 18.95 £ 9.95 Can.$ 25.95 SFR 27.50

teNeues